IMAGES
of America

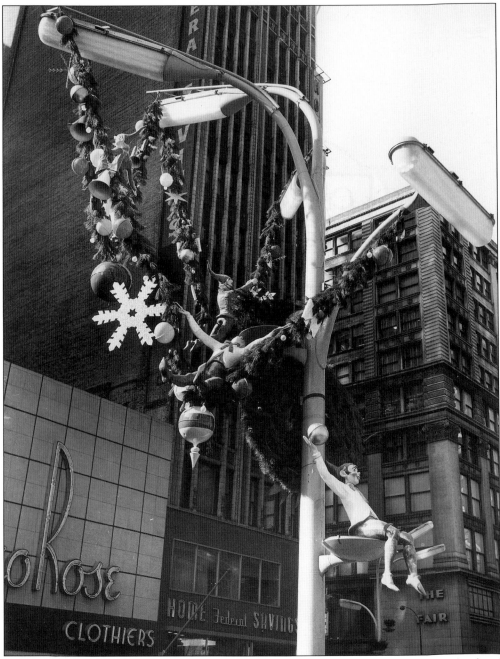

SANTA'S ELVES. The light post at the corner of State and Adams is decorated with garland and Santa's Elves in 1959. Businesses seen in the background include the Leo Rose Clothing Store, the Fair Store, and The Home Federal Savings and Loan. (Photo by Leonard Bass, used courtesy of The Greater State Street Council.)

IMAGES
of America

CHICAGO'S STATE STREET CHRISTMAS PARADE

Robert P. Ledermann

ARCADIA

Published by Arcadia Publishing,
Charleston SC, Chicago IL, Portsmouth NH, San Francisco CA

Printed in Great Britain.

Library of Congress Catalog Card Number: 2004104876

For all general information contact Arcadia Publishing at:
Telephone 843-853-2070
Fax 843-853-0044
E-Mail sales@arcadiapublishing.com
For customer service and orders:
Toll-Free 1-888-313-2665

Visit us on the internet at http://www.arcadiapublishing.com

Dedication

To Annette, Kaitlyn Rose, and Julia Marie. To all of you who are young and young at heart, may this book give you some joys of Holidays past and of a bright and shining future with new happy holiday memories to come . . .

(*cover*) THE 1950 CHRISTMAS PARADE. As in most of the Christmas parades, including this 1950 parade, Santa Claus himself was at the very end of the procession, on top the largest, most exciting float of all. Drawn by eight huge white reindeer, the red and white sleigh seen here was 160 feet long, making it the largest in State Street history. The parade crowds line both sides of State Street, filling the sidewalks and spilling into the street. (Photo courtesy of The Greater State Street Council.)

CONTENTS

ACKNOWLEDGMENTS

I wish to thank the numerous individuals who all assisted me in my research for this book. They shall always have my deep appreciation and gratitude.

Madilyn Mancini of the Museum of Broadcast Communications; Anthony (Tony) K. Jahn archivist/historian of Marshall Field's & Company; Julia Bentley, Senior Vice-President of Investor Relations and Communications of Carson, Pirie, & Scott Inc.; Kathy Weber, Administrative Assistant to Chairman and Chief Executive Officer of Carson, Pirie, Scott & Co.; Edward Carroll, Executive Vice-President of Sales Promotion and Marketing of Carson, Pirie, Scott & Co.; Cindy Sanchez, Regional Director of Human Resources of Carson, Pirie, Scott & Co.; Victoria Gonzalez, her assistant; Phil Purvich and Jamie Leavitt of the Chicago Festival Association; Ralph Hughes and Laura Jones of The Greater State Street Council (photographs, where noted, courtesy of the Greater State Street Council); Beverly Bricker; Van Gallios of Miller's Pub Restaurant; Mr. Herman and Mrs. Jan Berghoff of the Berghoff Restaurant; Jerry Sider, former Executive Director of The Greater State Street Council; John Pearson, Publisher, Arcadia Publishing; Chuck Schaden, *Those were the Days Radio* at WDCB College of DuPage; Helen A. Krysa of Walgreens; Tom Hebel, Vice-President of local programming at WLS-TV ABC–Chicago; John Schneider and Marilee Ferry of "The Trail's End Productions Inc. of Agoura Hills, California; Jim Tilmon of CBS-WBBM TV Chicago; Wally Phillips; John Conrad; Mary Ann Childers of CBS-WBBM TV Chicago; Lee Phillip Bell of Bell-Phillips Television Productions Inc. Los Angeles, California; Mary Hartline; Roy Leonard; Richard Tillstrom/ Copyright Trust of the Burr Tillstrom Trust; Harry Volkman of Fox-TV Chicago; Clark Weber; Bill Jackson/B.J. and the Dragon/The Fun Company; Dick Clark and Brian Pope of Dick Clark, Olive Enterprises Inc. Dick Clark Productions Inc; and Blair Kamin, *Chicago Tribune* Architectural Critic.

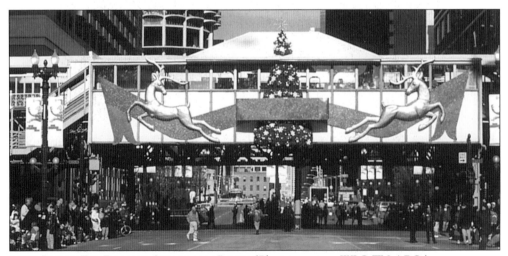

1997 JINGLE ELF PARADE–STATE AND LAKE. (Photo courtesy WLS-TV ABC.)

And I would be remiss if I failed to mention some of the fine people at Marshall Field's I had the pleasure to know in years past. The late Homer Sharp, the late Annette Lewin, the late Mrs. Johnny Coons, Virginia Paxson, Pat Parks, Johanna and Addis Osborne, and Sharon Roth.

Finally, I am grateful to the publications and books in the institutions that have helped me in my research to make this book a reality.

The Harold Washington Library of Chicago

The Marshall Field's Archives

The Chicago Historical Society

The Complete Encyclopedia of Television Programs, 1947–1979, published by A. S. Barnes & Co. written by Vincent Terrace ISBN 0-498-02488

The New York Times Encyclopedia of Television, by Les Brown, published by Times Books of NY. ISBN 0-8129-0721-3

The Town Crier newspaper column quote by Tony Weitzel

The Chicago Herald American

The Chicago Tribune

The Chicago Sun-Times

The Wall Street Journal

Herzog & Strauss / Marian Music of N.Y.

Broadway Music Corp. Will Von Tilzer President, 1619 Broadway N.Y. 10010

Music Sales Corporation & Aida Garcia, 257 Park Ave. South N.Y., N.Y. 10010

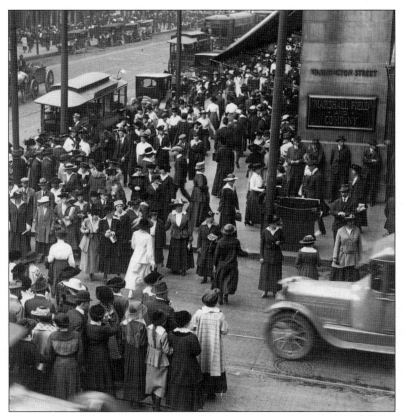

STATE AND WASHINGTON 1924. (Photo courtesy of Marshall Field's.)

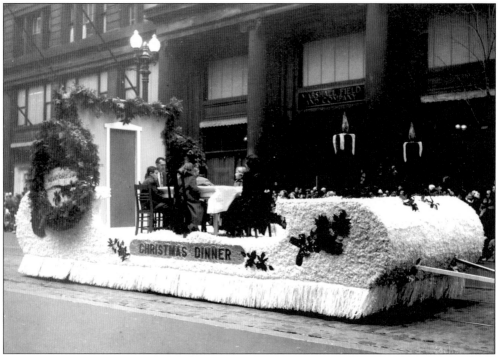

CHRISTMAS DINNER FLOAT OF 1948. (Photo courtesy of The Greater State Street Council.)

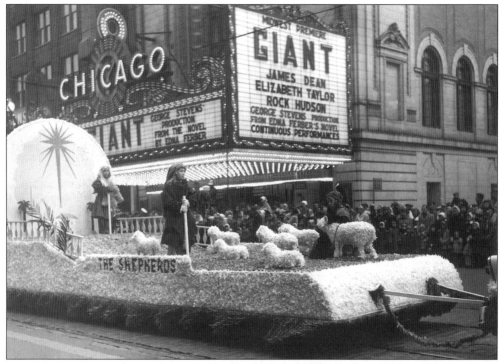

1956 CHRISTMAS FLOAT ENTITLED "THE SHEPHERDS." The Chicago Theater can be seen in the background. (Photo courtesy of The Greater State Street Council.)

INTRODUCTION

"I love a parade!" These words come into my mind every time I see a parade, but most of all when it's a Christmas Parade, and even more so when it is a Chicago Christmas Parade. Still today I look on with envy at the participants, lucky enough to be in the parade—the marchers playing their instruments with the school band, the Shriners in their special dress costumes, and the clowns working the crowds on the side curbs, filled with on-lookers. It must be a wonderful thing, to be in a parade. Perhaps because this is a part of my boyhood, I have been prompted to write this companion to my first book, *Christmas on State Street: 1940s and Beyond*. I remember back to the crowds, the cold weather, the department stores up and down State Street, with all their fabulous window displays, the lights and street decorations, and the great anticipation children have of seeing Santa Claus. I loved the excitement of the coming holidays, knowing Christmas Eve and Christmas Day were getting closer and closer and closer. The child cannot hold still for even a minute while he waits for Christmas—wanting it to come . . . now. One wonderful memory I have is of that old 17th-century traditional English Beggar's rhyme:

"Christmas is coming
The goose is getting fat
Please put a penny in
the old man's hat, —
If you haven't got a penny,
A ha'penny will do -
If you haven't got a ha'penny -
Then God Bless You!"

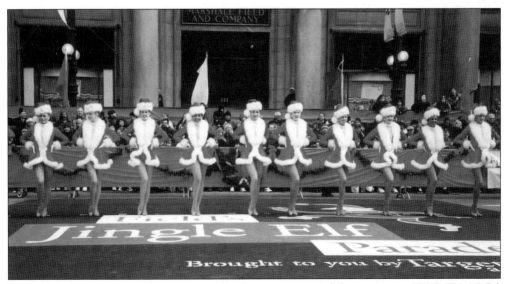

JINGLE ELF PARADE WITH THE FAMOUS ROCKETTES, 1999. (Photo courtesy WLS-TV ABC.)

9

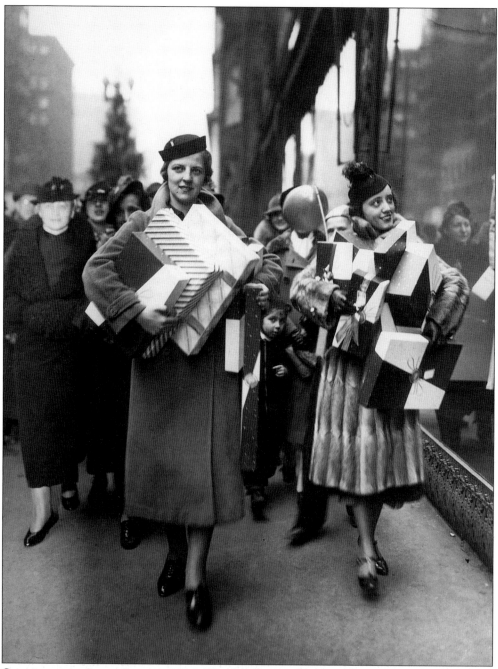

CHRISTMAS ON STATE STREET, 1936. The shoppers are Frances Rush and Claire Leith (Photo by Max F. Kolin, used courtesy of The Greater State Street Council.)

One
PARADES

Let's start at the beginning. To quote the *American Heritage Dictionary, Second College Edition,* "Parade–a public procession on a festive or ceremonial occasion." Where and when or who started the very first Chicago Christmas parade? Surprisingly enough, it was on December 7, 1934, when Walter Gregory, then President of the State Street Council (now the Greater State Street Council), thought up the idea to cheer up the people of Chicago during the hard Depression. The Mayor of Chicago, Edward Kelly, agreed and felt then it could also stimulate the economy and the development of State Street during the holidays. He was right, for it jump started the largest holiday buying period since 1927 for State Street and Chicago. He didn't call it a parade at all, but a Caravan.

The Caravan, led by Santa and Mr. Gregory, consisted of toys and merchandise from stores along State Street. This symbolized the Holiday Season and began the tradition of the Holiday Parades on State Street for years to come.

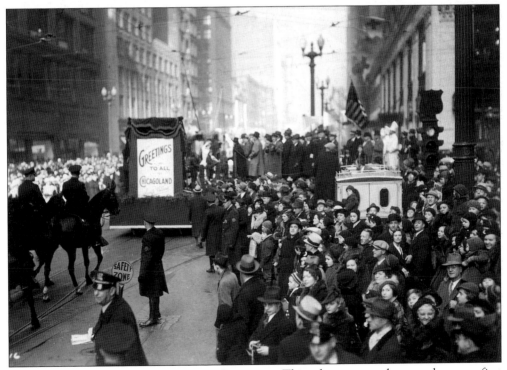

THE FIRST CHRISTMAS PARADE IN CHICAGO. This photo was taken at the very first Christmas parade in 1934. Note the chefs at the back of the reviewing stand. (Photo by Kaufmann and Fabry, used courtesy of The Greater State Street Council.)

CHICAGO CHRISTMAS PARADE FACTS

The parades last approximately two hours (with some of the older ones lasting a brief 40 minutes). The official name and exact location of the parade has changed over the years.

1934	"Caravan"—from Wacker Drive down to Congress on State Street.
1935–1983	"State Street Christmas Parade"—from Wacker Drive down to Congress on State Street.
1984	"The McDonald's Children's' Charity Parade"—on Michigan Avenue from Balbo up to Wacker Drive.
1990	"The Brach's Holiday Parade"—on Michigan Avenue from Balbo up to Wacker Drive.
1996	"The Brach's Kids Holiday Parade"—again on Michigan Avenue from Balbo up to Wacker Drive.
1998	"The Field's Jingle Elf Parade"—on Michigan Avenue from Balbo up to Wacker Drive.
1999	"The Field's Jingle Elf Parade presented by Target & Marshall Field's"—back on State Street again from Congress Parkway moving north to Randolph Street.
2002	"Target Thanksgiving Parade"—on State Street from Congress Parkway north to Randolph Street.
2003	"State Street Thanksgiving Parade"—from Congress Parkway to Randolph Street.

It was cold on the day of the first Christmas Parade, December 7, 1934. The weather was described in the *Chicago Daily News*: "A cold wave grips the city and sent the temperature down to abnormally low levels. The coldest spot in the middle-west, Galena, Illinois, registered 14 below zero." The first parade moved along State Street from north Wacker Drive, down to Congress Parkway.

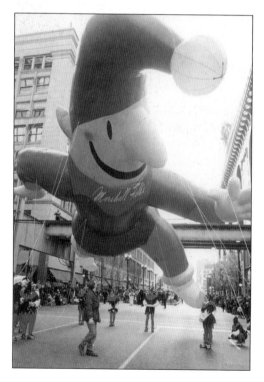

JINGLE ELF BALLOON ON STATE STREET IN **1999.** (Photo courtesy of Marshall Field's.)

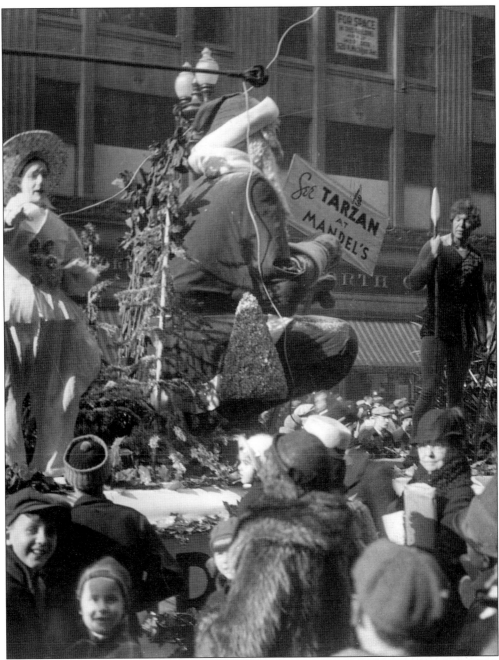

1934, The First Chicago "Caravan Parade." Seen here, the first Christmas parade, in 1934, featured Santa, Tarzan, and KoKo the clown from Mandel Brothers. Through the years, from their meager beginning, the Chicago Christmas Parades themselves had an exciting history. News was reported statewide of the stainless steel Burlington Zephyr sleek three-car train making its first 1,000-mile run non-stop on May 26, 1934 from Denver, Colorado to Chicago at 112 miles per hour. Its record shattering run was in connection with the Chicago Century of Progress.

The 1934 Caravan Parade was well received. A *Chicago Daily News* headline read, "Shoppers Besiege Loop; Sales Greatest since 1927." (Photo courtesy of The Greater State Street Council.)

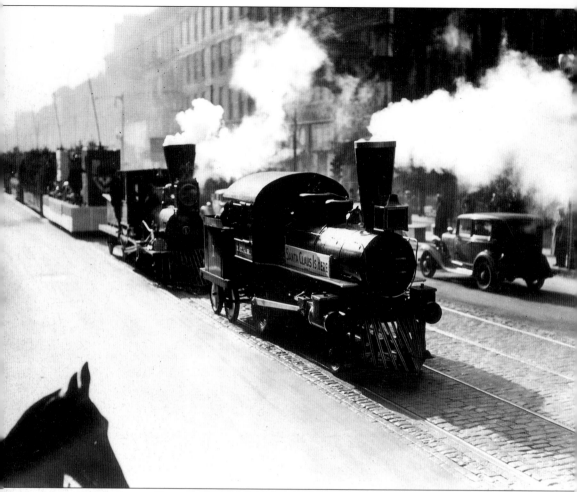

MINIATURE STEAM ENGINE. Opening the 1935 parade was this steam engine on the old State Street trolley tracks. You can just see the sign on the engine that reads "Santa is Here." Chicagoans watched their money closely, the job market was tight, and the city had to reign in its budget during the Depression years. In the 1935 Christmas Parade the floats were pulled along the trolley tracks that ran up and down State Street. Times were rough, but Chicago's motto "I Will" lived on. Even at the height of the Depression, Chicago still managed to pull together Christmas Parades that were welcomed by all. (Photo courtesy of The Greater State Street Council.)

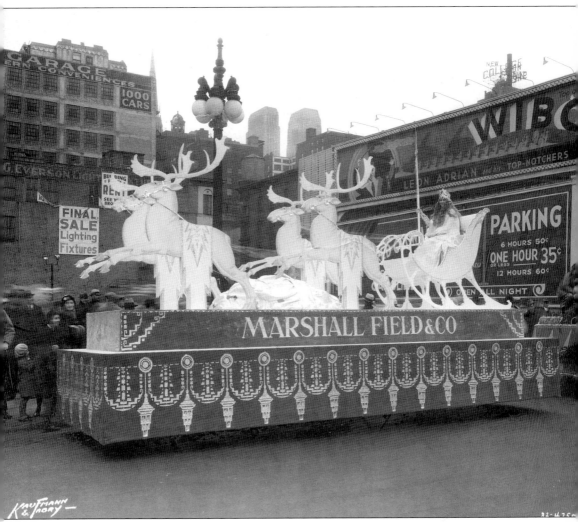

A Marshall Field & Co. Float from the 1930s. (Photo by Kaufmann and Fabry, used courtesy of Marshall Field's.)

AUNT HOLLY, UNCLE MISTLETOE, AND SANTA RIDING IN VINTAGE WAGON, 1975. (Photo courtesy of Marshall Field's.)

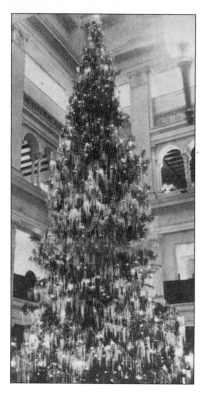

MARSHALL FIELD'S CHRISTMAS TREE OF 1938, FROM THE "FIELD GLASS." In 1938 the "State Street Carols" began. Christmas carols and additional holiday music would be heard on State Street through a sound-amplifying system that started December 16, 1938 and continued through Christmas Eve. This program was sponsored by the State Street Council. The council was founded in 1929 as a not-for-profit corporation, dedicated to promoting economic prosperity along State Street and the Downtown business district. The "Voice of State Street" studio was located in the Republic Building on north State Street. The music was transmitted through 24 giant loudspeakers mounted on stores and buildings from Lake Street to Congress. The big movie smash hit playing on State Street was *A Christmas Carol*, by Metro-Goldwyn-Mayer with stars Reginald Owen as Scrooge and Leo G. Carroll as Marley. And, as usual a huge 50-foot fresh balsam fir tree, said to be the largest ever to be brought indoors, stood in the Walnut Room of Marshall Field & Company department store on State Street. It weighed approximately 2,000 pounds standing on the seventh floor and extending up to the tenth floor of the building. It was decorated with 1,000 lights, 700 boxes of icicles, and 400 shining balls. (Photo courtesy of Marshall Field's.)

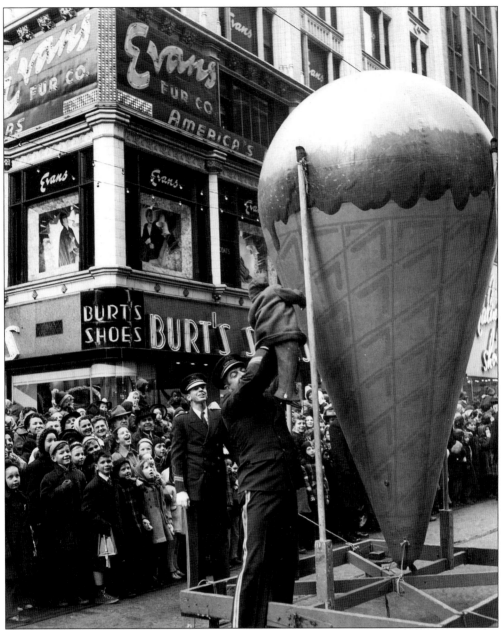

GETS A BOOST. Chicago youngsters look on a bit enviously as a small boy gets a boost from a helpful official during Toyland Parade in the State Street Parade of November 19, 1949. The cone was one of 25 giant balloons. Some measured 80 feet long as they were paraded along the "merchandise mile," which was packed with more than half a million parents and children. The climax of the parade was a glistening Santa float pulled by a huge golden deer.

The spirit of the season isn't just about merchandise, as I found in this little known story about Chicago. During the 1930s and '40s at Christmas time, when there was still some horse traffic on Chicago streets and alleyways, the Anti-Cruelty Society would quietly, without fanfare, distribute warm blankets and baskets full of fresh feed to the horses, especially the older, weaker ones. (Photo courtesy of The Greater State Street Council.)

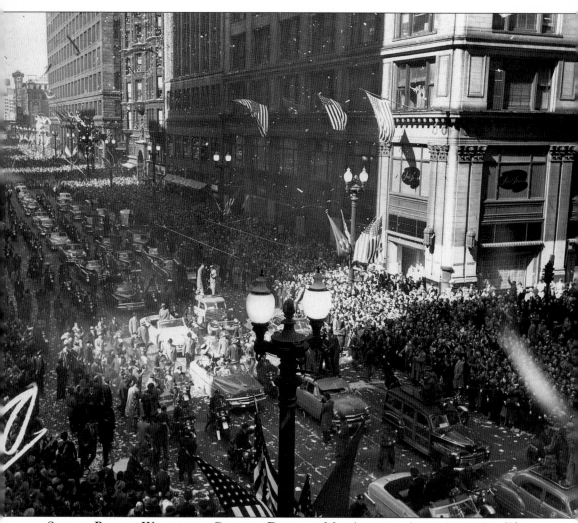

SPECIAL PARADE WELCOMING GENERAL DOUGLAS MACARTHUR, APRIL 26, 1951. (Photo from Acme Newspicture, used courtesy of The Greater State Street Council.)

In 1941 the Museum of Science and Industry, formerly called the Rosenwald Museum, started the Christmas Around the World display. Fir trees were decorated with traditional decorations from each country. Performers would sing carols from other countries, and show how the holiday was celebrated around the world.

State Street was closed to through traffic in 1940–1941 due to subway construction. Finally it reopened up to traffic as State Street on October 27, 1942, and the first subway trains ran beneath State Street on October 16, 1943. Everyone was happy their street was returned to them.

In the war years of the early 1940s, the parades, for the most part, reflected patriotic themes. And Chicago always threw a fantastic welcome home celebration for those returning home from serving their country. As World War II pressed on, work was hard and all over America, as here in the heartland, Chicago focused on lifting the mood of its people. There were many marching military bands, R.O.T.C. groups, and lots of flags everywhere.

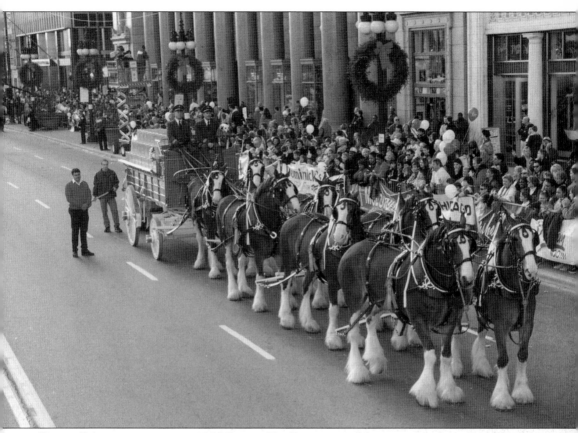

GREAT CLYDESDALES IN THE 1998 JINGLE ELF PARADE ON MICHIGAN AVENUE. In 1942 the tremendous Clydesdale Horses were invited to headline the annual event. With each passing year the Parades became more popular and spectacular. Local VIPs as well as national celebrities began to be seen at and around the parades. With World War II ending in 1945 one can only imagine the celebrations. Every military branch of service was welcomed and proud to be a page in Chicago's history! The Boy Scouts and Girl Scouts were encouraged to wear their uniforms and participate. Women's groups of the Red Cross and PTA sponsored local high school marching bands. All who marched seemed just a bit taller, straighter, and more patriotic with a lump in their throats that year. It must have been very thrilling to be in the atmosphere of that great special Christmas parade that ended the war! People's hearts were joyous and filled with encouragement, and why not—prosperity was just around the corner and Chicago residents were a big part of this new wave of peace. (Photo courtesy of Marshall Field's.)

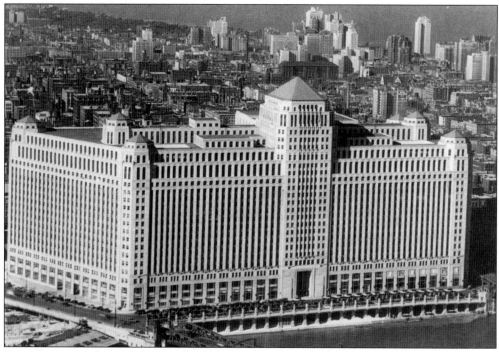

MERCHANDISE MART c. 1930S. By 1948 Chicago was on the map as a thriving television center. Original programs from famous broadcasting studios such as NBC, which broadcast from the 19th and 20th floors of the Merchandise Mart, won endearment in the homes of Chicagoland and the nation. In 1927, James Simpson, the president of Marshall Field's, announced that Field's would build the Merchandise Mart for the wholesaling of merchandise to retailers nationwide. The Mart was completed in 1930, and was sold in 1946 to Joseph P. Kennedy, the father of President John F. Kennedy. In 1999 the Kennedy family sold the Mart to Vornado Realty Trust. Christopher Kennedy, Joseph's grandson, has stayed on as executive vice president of Merchandise Mart Properties. (Photo courtesy of Marshall Field's.)

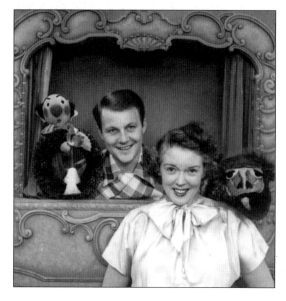

KUKLA, FRAN ALLISON, AND OLLIE WITH BURR TILLSTROM. All television was performed live, including *Kukla, Fran & Ollie* with Burr Tillstrom and Fran Allison, and Beulah Zachary as the original producer. Other shows originating in Chicago included *Hawkins Falls* (with Art Van Harvey and Bernadeen Flynn), *Stud's Place* (with Studs Turkel and Beverly Younger), *Ding Dong School* (with Dr. Frances Horwich), *Garroway at Large* (with Dave Garroway and his regulars Jack Haskell, Connie Russell, Cliff Norton, and Bette Chapel). Dave Garroway later went on to be the first host of NBC's *Today Show*, live from New York. (Photo courtesy of The Burr Tillstrom copyright Trust, Richard W. Tillstrom, Trustee.)

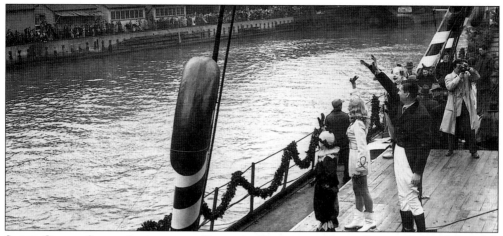

SUPER CIRCUS STARS ARRIVING AT TOYLAND PARADE ON RIVER BARGE. Pictured from left to right are Nicky the Clown, Mary Hartline, Cliffi the clown, and ringmaster Claude Kirchner. To mark the mid-century, Chicago pulled out all the bells and whistles. Bob Hope was the big Hollywood star in the November 19, 1949 Christmas Parade. The theme was "A Toyland Parade." Accompanying Bob Hope were the stars of the *Super Circus* television show. It was reported in the local newspapers that "Santa would arrive by boat." On the barge was Bob Hope, a group of football and baseball celebrities, the Super Circus personalities, and, of course, Santa Claus. The barge moved down the river, stopped at Wacker Drive, and was greeted by hundreds of fans and Mayor Kennelly, who proceeded with all the other Toyland characters down State Street. That year gigantic spotlights were focused on panoramas of Santa and his sleigh high above the street on the elevated "L" platforms facing State Street, at both ends, Lake on the north, and Van Buren at the south. Enormous reindeer were alternated by candy canes at each lamppost up and down State Street between Lake Street and Van Buren to complete the effect. (Photo courtesy of Mary Hartline.)

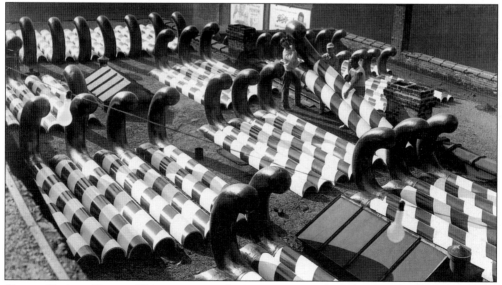

GIANT CANDY CANES. These giant candy canes are seen here being stored on top of the Silvestri Corporation roof. They would be put on all the lamp posts for the 1949 holiday season. (Photo courtesy of The Greater State Street Council.)

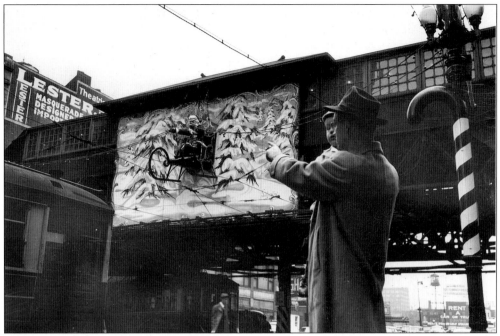

SANTA IN SLEIGH IN 1949. Santa's sleigh is seen here bursting through the Lake Street "L" structure at the corners of State and Lake. Note the candy canes on the lamp posts. (Photo by International News Photo, used courtesy of The Greater State Street Council.)

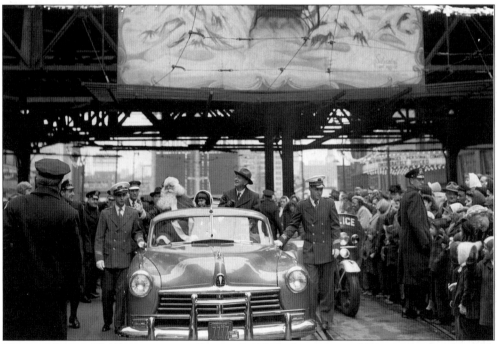

MAYOR MARTIN H. KENNELLY AND SANTA. In 1949, the mayor and Santa are riding beneath the Lake Street "L" accompanied by Andy Frain ushers and police escort. (Photo courtesy of The Greater State Street Council.)

Newspaper Ad Promoting the 1950 Mother Goose Theme. The 1950 parade had a Mother Goose theme that featured 54 characters from the various nursery rhymes. Old King Cole, Little Bo-Peep, Puss in Boots, and Mary Had A Little Lamb all were shoulder to shoulder with Mayor Martin H. Kennelly. He took great pride in accepting a police escort and being in the parade with a group of policemen, some of whom were riding their motorcycle scooters. That day, November 18, 1950 was a very special one for the Christmas Parade. Not only was it viewed by the half million people along State Street, it was, for the first time, broadcast on television. The State Street Council recognized along with the mayor that there was no reason why Chicago's Christmas Parades could not compare favorably with those of other cities, including New York's Macy's Parade and the parades in Philadelphia and Detroit.

Old King Cole in 1950 Parade on Lamp Post Figure. (Photo courtesy of The Greater State Street Council.)

23

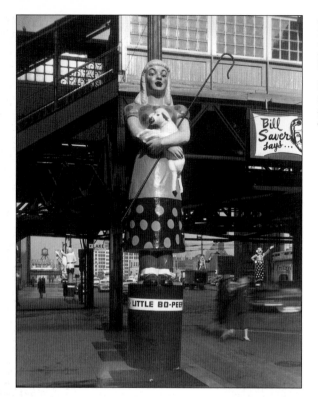

LITTLE BO PEEP. This Little Bo Peep figure is attached to a lamp post in 1950 in front of Lake Street "L." To the right in the background is the famous Fritzel's restaurant, noted for the celebrities who frequented it. (Photo courtesy of The Greater State Street Council.)

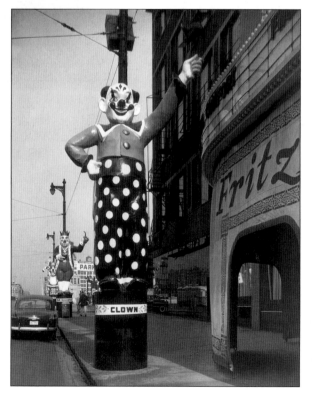

CLOWN FIGURE ATTACHED TO LAMP POST. This 1950 photo shows a close-up of one of the clown figures; the entrance to the old Fritzel's restaurant is visible on the right, and Old King Cole is in the background. (Photo courtesy of The Greater State Street Council.)

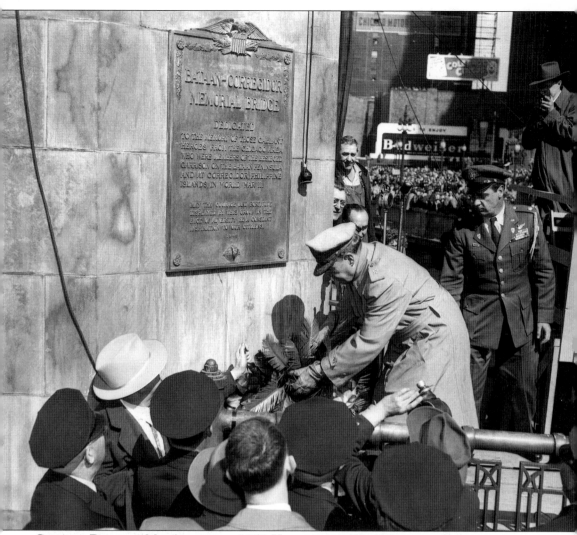

GENERAL DOUGLAS MACARTHUR IN 1951 VISITING THE WAR MEMORIAL PLAQUE AT THE STATE STREET BRIDGE. In 1951 the Chicago parade welcomed two diverse personalities—cowboy favorite Hopalong Cassidy, astride his famous horse, Topper, and General Douglas MacArthur. General MacArthur had also come to town earlier in the year for a commemorative military celebration and to visit the War Memorial plaques on the Chicago River Bridge. The press had a field day, and it was great publicity for Chicago. The 1953 Christmas Parade welcomed Roy Rogers and Dale Evans as honored guests. (Photo courtesy of The Greater State Street Council.)

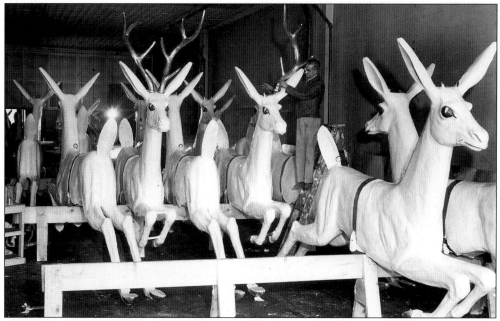

SANTA'S REINDEER, 1950. This group of reindeer was used in the 1950 parade on Santa's largest float. Each reindeer weighed 450 pounds. (Photo by Where What When Inc., used courtesy of The Greater State Street Council.)

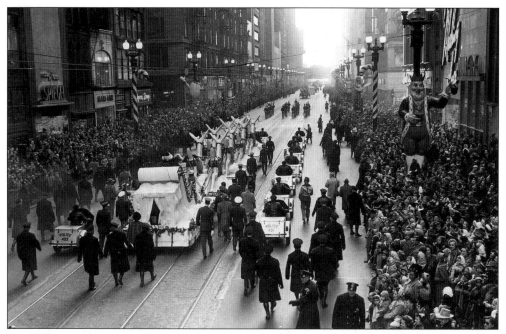

STATE STREET PARADE, 1950. Also on the cover, this photo shows the largest float ever used in the parade. Santa pulled up the rear of the parade in the 160 foot long float. That year too brought some of Chicago's biggest industrial names as sponsors, including Borden Dairy, Admiral Radio, Oscar Mayer, Mars Candy Inc., Bowman Dairy, The First Federal Savings and Loan, and The Silvestri Art Mang. Co. (Photo courtesy of The Greater State Street Council.)

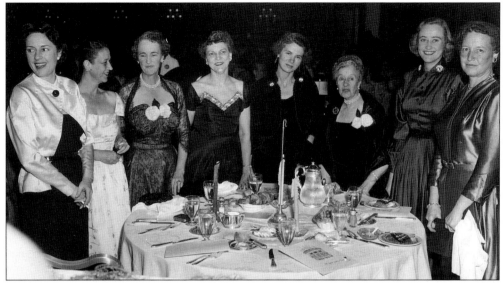

CARSON, PIRIE, SCOTT & CO. 100TH ANNIVERSARY DINNER, JANUARY 20, 1954. Pictured from left to right are Mrs. W.W. Cole, Mrs. David Mayer, Mrs. John T. Pirie, Jr., Mrs. Arthur Hall, Mrs. Hughston McBain, Mrs. John T. Pirie, Sr., Mrs. Marshall Field, and Mrs. Elmer T. Stevens. Carson's 100th anniversary dinner was a huge shindig featuring a who's who of State Street VIPs. Another honored guest was radio and TV personality Herb Shriner. (Photo courtesy of The Greater State Street Council.)

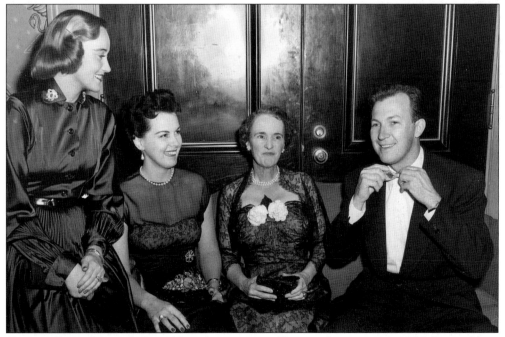

CARSON, PIRIE, SCOTT & CO. 100TH ANNIVERSARY DINNER, JANUARY 20, 1954. Pictured from left to right are Mrs. Marshall Field, Mrs. Joel Goldblatt, Mrs. John T. Pirie, Jr., and honored guest, the radio and TV personality Mr. Herb Shriner. (Photo by Chicago Photographers, used courtesy of The Greater State Street Council.)

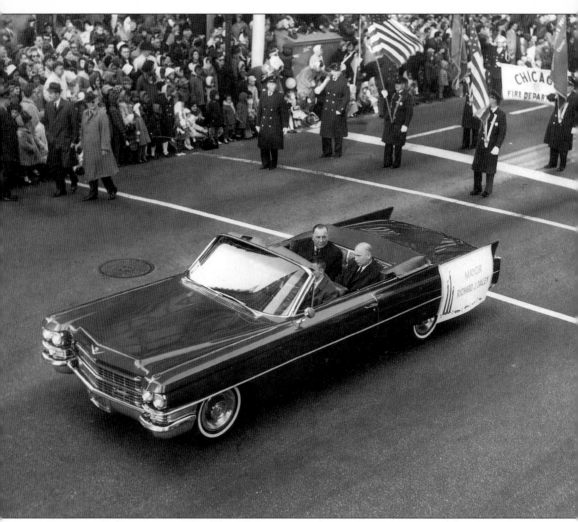

RICHARD J. DALEY IN 1962. The Christmas parades were getting more elaborate and with each passing year it was apparent that these parades were in fact a win-win place to be seen. Politicians began to take an unusual interest in being part of the activities. In 1955 Governor William Stratton and Senator Everett Dirksen took time out of their busy schedules to crown the Star Queen in an elaborate ceremony prior to the annual parade.

The parades became so long and so expensive to put on that in 1967 the State Street Council said they could no longer keep up the expense to sponsor or organize the annual Christmas Parades. Chicago's mayor at the time, Richard J. Daley, and his office appointed Col. Jack Reilly as the Director of the Mayor's Office of Special Events. Col. Reilly would now be responsible for working with the city merchants and sponsors to produce all of the future parades up through 1983.

For those 16 years, from 1967 to 1983, City Hall used its political connections to get more involvement from local teamsters and local companies. These parades featured local school marching bands, service leagues, firemen, policemen, drum and bugle corps, ethnic organizations, plumbing council, electrical workers, pipe fitters, printer's union, and car dealerships that provided beautiful convertible automobiles for the parades. (Photo by Town & Country, used courtesy of The Greater State Street Council.)

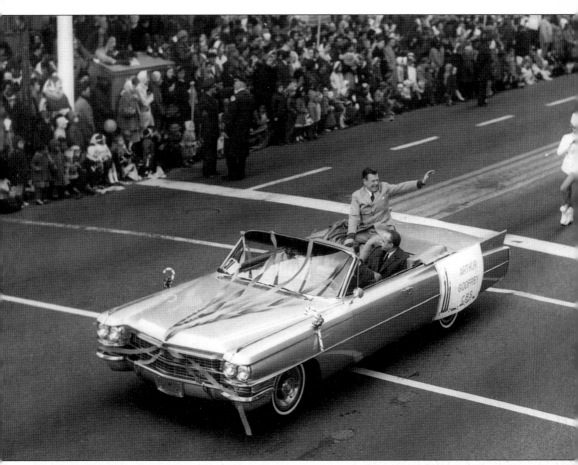

Arthur Godfrey Lends his Celebrity Presence to the Parade, Sponsored by CBS, in 1962. "Christ in Christmas" was the 1961 theme, with the Nativity emphasized throughout the parade. It was televised for the 12th consecutive time. Radio and TV star Don McNeill was the master of ceremonies. Annette Funicello came to Chicago to do a publicity plug for Walt Disney's newest production, "Babes in Toyland." The special guest star was Dick Clark of "American Bandstand."

Chicago's own Lee Phillip, now Mrs. Lee Phillip Bell of TV soap operas *The Bold and the Beautiful* and *The Young and the Restless*, rode in the parade of 1963 promoting *The Friendship Show* on WBBM-TV Channel 2 Chicago.

The 1969 Chicago Christmas Parade celebrated its 35th anniversary with huge fanfare. With everyone working together towards one goal, the council and the city planners were constantly striving to promote Chicago as the strong city it still is today. The associations from Wabash and Michigan Avenues and the west Loop area, along with the Chicago Central Area Committee, The Chicago Convention and Tourism Bureau, the Illinois Retail Merchants Association, The Chicago Association of Commerce and Industry, and the Better Business Bureau all were solid backers and advisors of these Christmas parades of the 1960s and 1970s.

In 1975 State Street shoppers had the convenience of a free Santa Claus bus service. A north-south, east-west route operated during the holiday season. The Salvation Army's brass band was always a traditional sight to see playing tunes on the corner of State and Madison.

State Street celebrated America's bicentennial in 1976 with a spectacular Red, White, and Blue patriotic Christmas Parade. (Photo by Town & Country, used courtesy of The Greater State Street Council.)

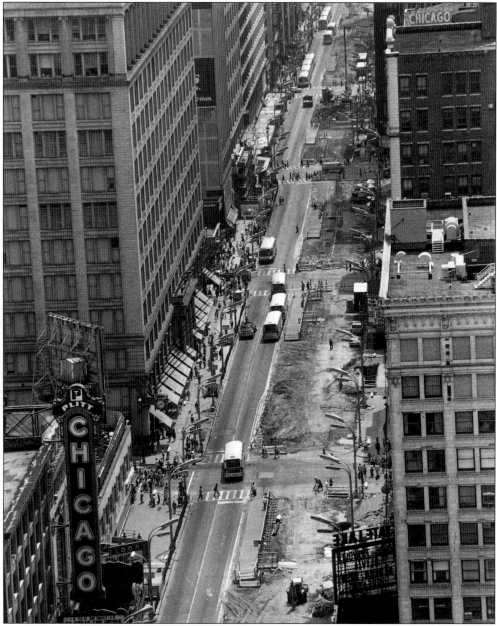

1978 AERIAL VIEW OF STATE STREET, LOOKING SOUTH FROM LAKE STREET. The 1978/79 Christmas parades became a real issue with the city planners. The tremendous problem was where to have the usual nine-block parade. In 1978, the street belonged to the bulldozers—State Street was going to become a "Mall." The parade was moved over to Michigan Avenue until 1981, when it moved back onto State Street. The Honorable Mayor at that time was Jane Byrne who wanted something spectacular for the first Christmas parade on the Mall. On that morning she had Santas lined up from curb to curb, starting the parade, their hands filled with over 10,000 balloons, which they passed out to the estimated 500,000 parade watchers. She herself watched the parade go by from the largest reviewing stand ever erected at State and Madison. (Photo courtesy of The Greater State Street Council.)

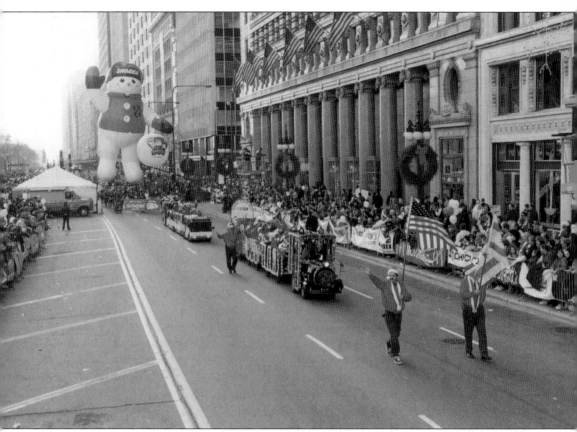

1998 JINGLE ELF PARADE ON MICHIGAN AVENUE. (Photo courtesy of Marshall Field's.)

In 1983 rumor had it that there might not be a parade that year. New Mayor Harold Washington and his administration determined that there was no money available in the budget for any holiday parade. One of his campaign cornerstones was "to cut the fat on spending." However, since the parade was planned and the funds were in trust by the previous administration, it was agreed a smaller parade could be held. So in 1983 a slimmed down "static" parade was held on State Street even though it was the 50th anniversary of the very first Chicago Christmas Parade. Briefly in 1984 the parade leadership again passed hands and was directed and run by the "Production Contractors Inc. Company," who throughout the year looked for a permanent director to run the parade. They found what they needed in the McDonald Corporation Owners of Chicagoland and of Northwest Indiana. This new sponsor took on the leadership and launched the McDonald's Children's Charity Parade, but decided to move it over to Michigan Avenue again to accommodate the larger and bigger floats. After only a brief six years of control, the McDonald's Corporation announced that they could no longer serve as the parade's sponsors, due to a shift in their marketing strategy. During those six years they did put on a fantastic parade. Under their support and financial sponsorship, those holiday parades were usually a two-hour special on WLS-TV that was televised nationally via satellite by 110 stations to an estimated 70 million households.

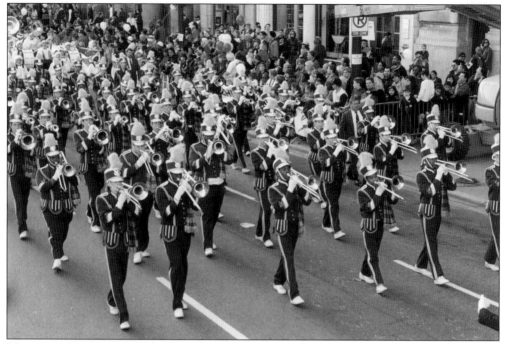

MARCHING BAND ON MICHIGAN AVENUE, 1998. (Photo courtesy of Marshall Field's.)

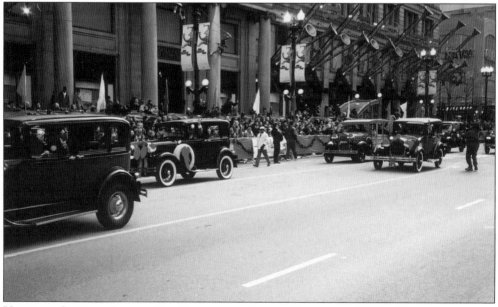

VINTAGE CARS IN JINGLE ELF PARADE ON STATE STREET IN 1999. (Photo courtesy of WLS-TV ABC.)

GINGERBREAD MAN FLOAT OF 1998 ON MICHIGAN AVENUE IN JINGLE ELF PARADE. (Photo courtesy of Marshall Field's.)

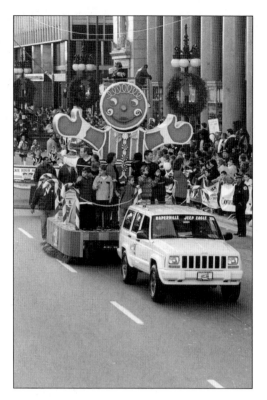

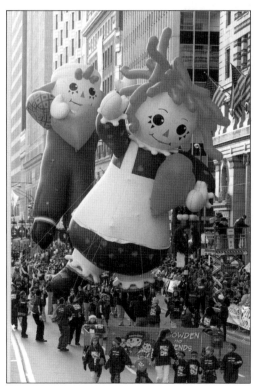

RAGGEDY ANN AND ANDY FLOAT. In 1990 the parade once again got a new sponsor—the Brach and Brock Confection Company. The new name for the parade was "Brach's Holiday Parade" in 1996 it was renamed once again to "Brach's Kid's Holiday Parade." These new Christmas parades emphasized the most important parade viewers . . . the children. Brach's proved to be a highly successful sponsor for 8 years. During the 1994 holiday parade, the cast members from *Joseph and the Amazing Technicolor Dreamcoat* with Donny Osmond and the Chicago Children's Choir were honored parade guests. (Photo courtesy of Marshall Field's.)

33

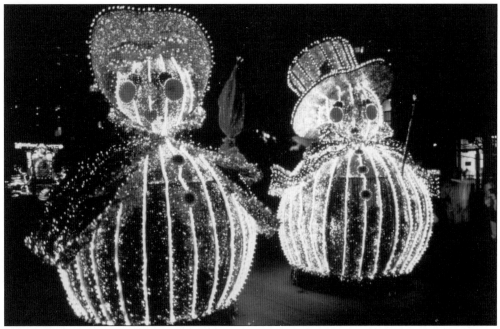

THE 14-FOOT SNOWMAN AND SNOW WOMAN DOODLE BUGS. They spin and twinkle in the crisp night air, brilliantly lit from head to toe with colorful Christmas lights, enveloping onlookers in holiday cheer. (Photo courtesy of WLS–TV, ABC.)

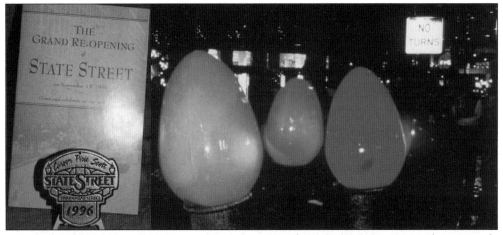

LIKE A CHRISTMAS DREAM COME TO LIFE. On November 15, 1996 a very special new parade was put on by Marshall Field's. "The Marshall Field's Holidazzle Parade" parade celebrated the unveiling of the new and improved State Street. It was a spectacular fairytale procession with 200,000 strings of brilliantly lighted floats with storybook and nursery rhyme characters. *Alice in Wonderland, The Princess and the Pea,* and *The Old Woman Who Lived in the Shoe* were some of the ones featured. In addition, Marshall Field's popular Jingle Elves made their live debut. The Mall was gone—State Street was ready that year for its reopening to traffic with new historically inspired 1920s lamp posts. The inset shows the 1996 Official Booklet of the Grand Re-opening of State Street and the official hand cast, solid pewter keepsake ornament that was given out with every purchase at Carson, Pirie, Scott & Co. (inset photo, R.P. Ledermann, main photo courtesy of WLS–TV ABC.)

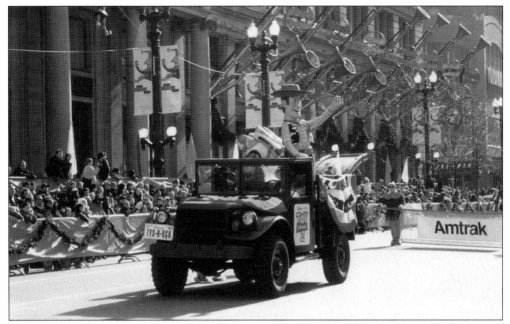

WOODY AND BUZZ FROM *Toy Story* IN JEEP ON STATE STREET IN 1999. In 1998 Marshall Field's took over the sponsorship of the parade and established the "Field's Jingle Elf Parades." The holiday theme was "Visions of Christmas on State Street" and included not just a fantastic Christmas parade, with Santa and Elves, but also for the first time—pyrotechnics! In 1999 Target joined Marshall Field's as the presenting sponsor and renamed the parade "Field's Jingle Elf Parade presented by Marshall Field's and Target." They moved the parade route back to State Street from Congress up to Randolph. It is interesting to note that the 1999 parade was the first time since its beginning the parade was actually on Thanksgiving Day. As a result of a changing marketing focus, in 2002 Marshall Field's left the role as title sponsor, but Target remained on. The 2002 parade was named "The Target Thanksgiving Parade." Target owns Marshall Field's Corporation, but as of this writing has announced it is looking for a buyer. (Photo courtesy of WLS–TV, ABC.)

DENNIS FRANZ, JANET DAVIES & JIM ROSE IN BROADCASTING BOOTH OF HOLIDAY PARADE, 2000. (Photo courtesy of WLS–TV, ABC.)

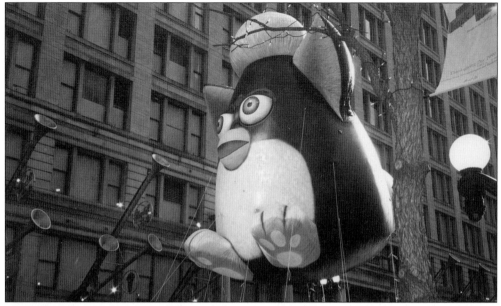

TOY CHARACTER "FURBEE" HELIUM BALLOON ON STATE STREET IN 1999 HOLIDAY PARADE. (Photo courtesy of WLS–TV, ABC.)

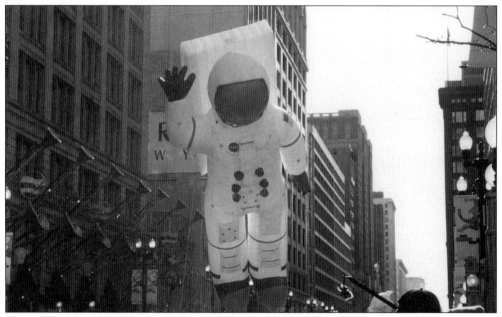

MAN IN SPACE HELIUM BALLOON, 1999 HOLIDAY PARADE ON STATE STREET. Have we come full circle? The December 25, 1988 *Chicago Tribune Magazine* article "Flashback," quoted an article written in 1908, entitled "How Christmas will be Celebrated 100 Years from Now." It envisioned some interesting things, including 245-story skyscrapers, with giant communal kitchens that delivered holiday meals by automatic dumbwaiters, talking dolls, mechanical dogs, and a home "telautoscope" on which to watch plays and other live events. It's almost 100 years since 1908, and some of these things are already here. I don't know what Christmas will be like 100 years from now, but I believe there will still be a parade. (Photo courtesy of WLS–TV, ABC.)

Two
CELEBRITIES

What is a Chicago Christmas parade without celebrities? There's nothing like it. Of course if you ask a child, their favorite will always be seeing Santa Claus. Teenagers would enjoy seeing a rock star. A senior citizen likes visiting the past, seeing an old movie star, "old timer" or perhaps a local politician. Chicago's Christmas parade had them all and more. Movie stars, generals, puppet personalities, television celebrities, you name it, Chicago had them. A couple of favorites were the cowboy heroes, Hopalong Cassidy, riding his famous horse Topper, and Roy Rogers and his horse Trigger. The famous and the soon to be famous were all here in our parades; even the local patrol boy marching with his school band. In this chapter you'll visit with some of Chicago's guests who were all kind enough to remember and share with me some of their Christmas memories. An enormous "thank-you" to each and every one of them.

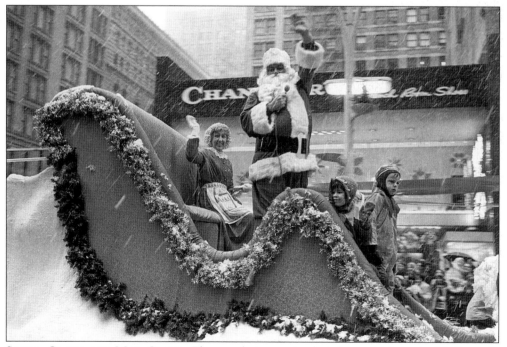

SANTA CLAUS AND MRS. CLAUS. The couple is seen in their huge sleigh in the 1968 parade as snow falls around them. Chandlers shoe store can be seen in the background. (Photo courtesy of The Greater State Street Council.)

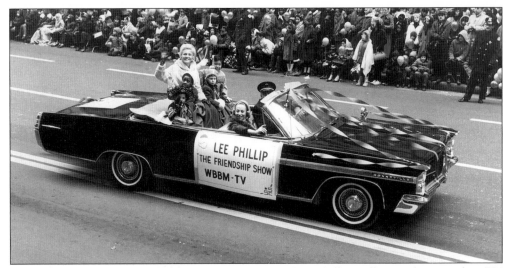

Lee Phillip Bell, an Honored Guest in 1963. Lee Phillip Bell was Chicago's first TV weather lady, and she had her own talk show featuring local interests, interviews, and shopping tips. She is married to Bill Bell, the creator of the daytime soap operas *The Young and the Restless* and *The Bold and the Beautiful.*

Lee remembers: "First, being born in Chicago my mother loved going down to the loop and taking me to Marshal Field's. She loved to do this especially at Christmas time where we would stop and go to the Marshall Field's Christmas Center for lunch. We always sat next to the giant Christmas tree. I don't remember when we first went there because I was too young, but I do remember going there every Christmas for at least 40 years. As a young child, I looked at the tree and thought it was the largest tree I'd ever seen and the ornaments were spectacular. Large balls covered by glittering ribbon, pine cones and stars. There were candy canes and figurines of toy soldiers and fairy princesses. There were also beads and everything else you can imagine.

A year after I graduated from Northwestern University, my application for a job with the Cook County Welfare Department as a third class social worker was accepted and they happened to call me on the same day that station W.B.K.B. called and asked me if I would substitute for Lucky North for two weeks while she was visiting Japan. I thought the job at the W.B.K.B would last just a short time so I called the Cook County Welfare Department back and told them that I would call back in two weeks. Then, I called W.B.K.B and told them I would take the job.

"I had been working for my Dad at his flower shop, so I told my Dad I was going to be an announcer and handle Lucky's job for two weeks of a noon interview show, commercials on the afternoon movie and a shopping show at 5:30 p.m. As an announcer I started rehearsal at 7 a.m. and signed onto the station at 7:55 a.m. Then I read the Morning Prayer and did a public announcement for one minute. It sounds easy but it was very difficult for me because I had never taken any speech courses at Northwestern. The night before I was reading a book into the tape recorder and the next day I started.

"The first day on the job was meeting Frank Reynolds, Vera Ward, Carmelita Pope, John Harrington etc.. I announced from 7:55 a.m. until 6 p.m., did a show at 10:30 a.m. on television, than back to announcing. In the morning Arthur Godfrey was on, then Gary Moore from 11 a.m. to 12 p.m. At 12 p.m. I went down to the drug store for a sandwich and at 1 p.m. Art Linkletter was on. At 2 p.m. a motion picture started and I went in during commercial breaks to do several commercials along with Frank Reynolds. At 5 p.m. when the motion picture ended, Fahey Flynn did the news and John Harrington did sports and then it was my turn to give shopping tips during the *Shopping* show." (Photo by Town & Country Photographers, used courtesy of The Greater State Street Council.)

Lee Phillip with Good Friend Wally Phillips in 1981. (Photo by Coleman King, used courtesy of Wally Phillips.)

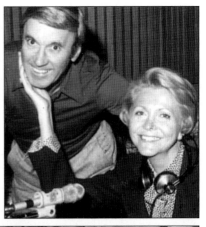

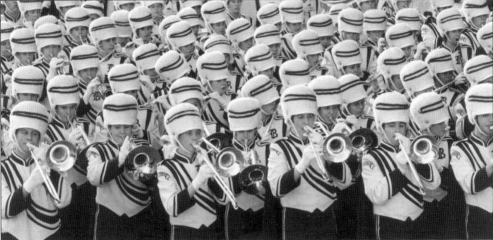

Jingle Elf Parade Marching Band 1998 on Michigan Avenue. Mary Ann Childers of Channel 2, CBS Chicago television shared these remembrances with me during a phone interview.

"I can remember an extremely cold and rainy parade on Michigan Avenue. Dick Johnson and I were promoting the United Cerebral Palsy telethon for Channel 7. We were to be on a huge float with Mickey and Minnie Mouse and Pluto. With the inclement weather, the Evans Fur Store graciously permitted us to wear some wonderful furs. I can remember mine was a warm white fluffy coat. We were at the Blackstone Hotel enjoying a cup of coffee, when we discovered we all should be on our assigned float, but were not. What to do? Frantically we jumped into two police cars and started racing up Wabash Avenue, peeking through at intersections towards Michigan Avenue to catch up with the parade. We all finally caught up with the parade almost at the very end, right at the Tribune Tower at the bridge. To make the long story short, we were all there, being seen by the reviewing stand, with none other than Oprah Winfrey and the late Robert Ulrich with looks on their faces that could only be explained as a 'Kodak moment'. . . 'And just where in the heck have you guys been?' I'll never forget those looks or my beautiful coat all ruined by the rain.

"I grew up in Louisville, Kentucky. The weather at the holidays was similar to that Christmas Parade in that it was cold, damp and rainy. One year I can remember, it got really cold and it snowed on Christmas Eve—it was magical. It was my very first White Christmas with all that lovely snow everywhere. My sister and I always looked forward to our Christmas stockings filled with goodies for us. The best presents were always tucked safely into the toes." (Photo courtesy of Marshall Field's.)

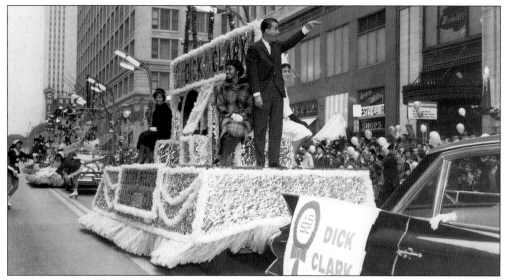

DICK CLARK IN FRONT OF WIEBOLDT'S DEPARTMENT STORE IN 1961. Dick Clark, has been the host of *American Bandstand, The Original $10,000 Pyramid, TV Bloopers and Practical Jokes* and many other shows, as well as the annual New Year's Eve celebration from New York's Times Square. His comment on remembering this old photo was "I can't believe I was standing outside in Chicago winter weather in just a suit coat." (Photo by Town & Country, used courtesy of The Greater State Street Council.)

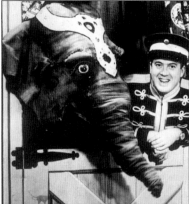

JOHN CONRAD WITH ELMER THE ELEPHANT. John Conrad started as a page-boy in Chicago at NBC Channel 5 television working his way up to broadcaster for a span of 23 years. For five years Conrad was the star of the NBC children's show *Elmer the Elephant*, which he also produced and wrote. Today, after moving on to California he is again a success as the owner of Alpine Air Purification Systems of Los Angeles, specializing in air filtration and air quality. He is in partnership with William Eckstram of Global Consumer Services Inc. Together they are developing a system to help handicapped children with severe asthma. He shared some of his recollections of Christmas in Chicago.

"The State street Christmas parade attended by a least 100,000 kids and parents was always a highlight of my years on NBC television. Seeing and hearing the cheering kids gave me a warmth that remains in my mind to this day. Elmer's house, built exclusively for the Christmas parade, was on a large float with a stage area in front of the house. Kenny Herrmann, an NBC stagehand, was inside Elmer's head and deserves credit for making Elmer the lovable, almost human comic that he was. Inside the house Elmer had a stagehand assistant who handed him what he needed to set me up for a prank. One of our favorite routines was the release of giant balloons as we came down State Street. Backstage a hose inside Elmer's trunk was connected to a helium tank. The kids would see a balloon being blown up by Elmer, I would turn to my right, purposely to avoid seeing what he was doing, and ask Elmer if he was doing anything. Hiding the balloon from my line of sight he would shake his head NO. The kids loved it when he released the balloon. Helium filled, it rapidly rose skyward between tall State Street buildings. Seeing the looks of joy on the faces of Elmer's fans was all Kenny Herrmann and I needed to make our day." (Photo courtesy of John Conrad.)

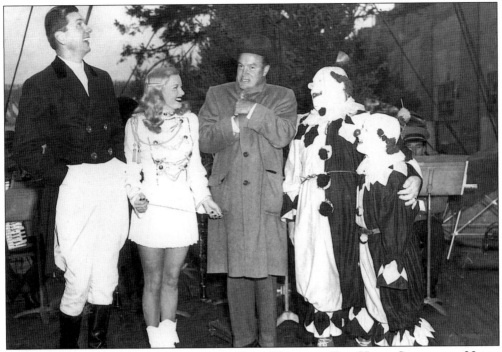

SUPER CIRCUS STARS CLAUDE KIRCHNER, MARY HARTLINE, BOB HOPE, CLIFFY, AND NICKY ON RIVER BARGE. Mary Hartline was the band mistress and queen of the *Super Circus* television show, produced in Chicago from 1949 through 1956, from the studios of WBKB (now WLS). Featured with Mary was Claude Kirchner as ringmaster. The clowns, known as Scampy, Cliffy, and Nicky were her fun companions. In a phone interview, Mary shared with me her memories of the day both she and the Super Circus gang accompanied the late Bob Hope on that river barge that started the Christmas Parade. She sent a newspaper clipping that she had saved all these years because she enjoyed his quote about her from *The Town Crier*, in a story written by Tony Weitzel. "Sailing up (I mean down) river, he bathed beautiful blond Mary Hartline of *Super Circus* in the warm Hope smile. Mary's scanty costume was showing a gorgeous pair of Hartline legs. 'Kid,' sighed the appreciative Mister Hope, 'you look better in goose pimples that most gals do in minks!' " (Photo courtesy of Mary Hartline.)

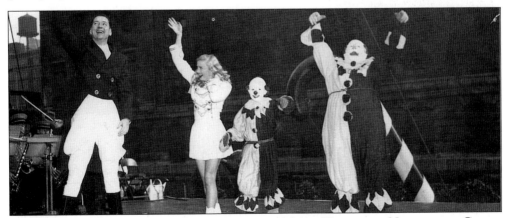

WAVING TO THEIR FANS—CLAUDE KIRCHNER, MARY HARTLINE, NICKY, AND CLIFFY. (Photo courtesy of Mary Hartline.)

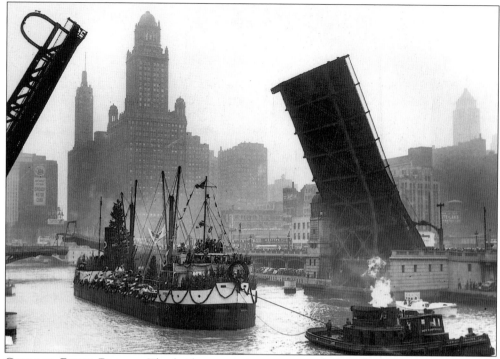

CHICAGO RIVER BRIDGE. The bridge opens its arms to welcome the Christmas Barge with *Super Circus* stars and Bob Hope, escorted by a tug boat. (Photo courtesy of Mary Hartline.)

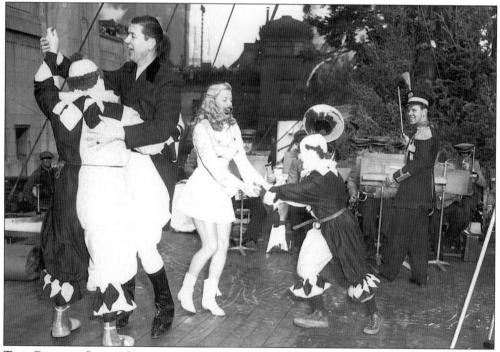

THE CAST OF SUPER CIRCUS HAS FUN ON THE CHRISTMAS BARGE. (Photo courtesy of Mary Hartline.)

B.J. & THE DRAGON RIDING IN MODEL-T DRAGON WAGON. Bill Jackson, famed TV puppeteer of the children's show *B.J. and the Dragon*, had these words to say: "I had a 1917 Model-T truck called the Dragon Wagon. With myself and my puppet characters waving to one and all, we had just passed Mayor Daley's reviewing stand and started across the State Street bridge, when the Model-T's radiator erupted like Mt. Vesuvius, halting the entire parade. A heavily braided police officer who had been at the Mayor's side strode with jut-jawed determination to our smoking, hissing float and directed us to 'move it or lose it.' We moved it. But to do so, we had to use an illegal towing strap. The officer didn't seem to care." (Photo courtesy of "Copyright 2003 ©, Bill Jackson.")

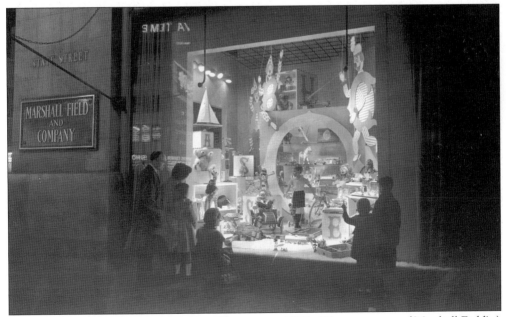

A MARSHALL FIELD'S CHRISTMAS TOY WINDOW OF 1963. (Photo courtesy of Marshall Field's.)

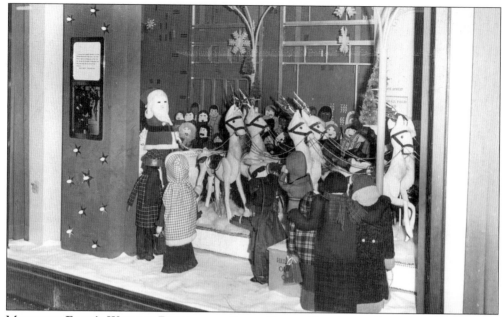

MARSHALL FIELD'S WINDOW DEPICTING A STATE STREET CHRISTMAS PARADE c. 1970S. The photo below shows papier-mâché soldiers that were used in the 1930s Christmas windows.

Roy Leonard has been one of the great Chicago media personalities for as long as most of us can remember. He has been a movie and theater critic, an announcer and radio talk show host for WGN, and hosted *Family Classics* on WGN-TV following the late Frazier Thomas. He was gracious in sharing his Chicago Christmas memories. "How can you make it less

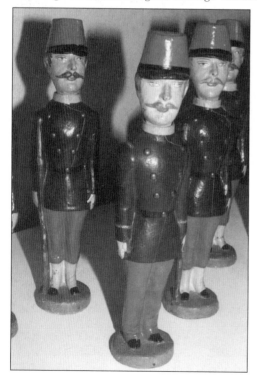

traumatic for a family move that takes six little boys, ranging in age from one to twelve, and a wife who had never been West of the Hudson River, half way across the country and far away from friends and familiar surroundings? Chicago's famed State Street came to the rescue in the late 1960s, when I accepted an offer to join WGN Radio/TV. Leaving the Boston area where we had lived and worked all our lives was a tough move, especially at Holiday time. But peering into the windows of Marshall Field's and then having lunch beside the huge Christmas Tree in the Walnut Room, provided a perfect escape that became a tradition, as it has for generations of Mid-West families. And it was not only at Christmas time that we made the trek downtown. My wife's Irish heritage got a big boost when she first saw Mayor Richard J. Daley lead the St. Patrick's Day parade up that 'Great Street.' Times may have changed, but the memories linger on." (Top photo courtesy of Marshall Field's, bottom photo courtesy R.P. Ledermann.)

WALLY PHILLIPS WITH MAYOR JANE BYRNE IN 1980. It was approaching Christmas 1969 and Wally had heard about the children and family welfare caseworkers digging deep into their own pockets to provide a small contribution to the families listed in their files. From that meager beginning a great charity arose. With support from Wally, the Neediest Children's Fund was begun. Through the generosity of his listening audience and friends, Wally has raised over 25 million dollars to help children.

It was the summer of 1947 when Wally stood quaking before a lectern in the studios of WJEF (Grand Rapids, MI), dreading his first words as a radio announcer. Arthur Godfrey was on the CBS network in New York and Wally's only responsibility during their station break was to say: "This is WJEF, Grand Rapids." What came out was "This is WEJF, Grand Rapids," but Wally was on his way nonetheless. He worked for three Cincinnati stations before coming to Chicago and WGN in October of 1956. (Photo by Coleman King, used courtesy of Wally Phillips.)

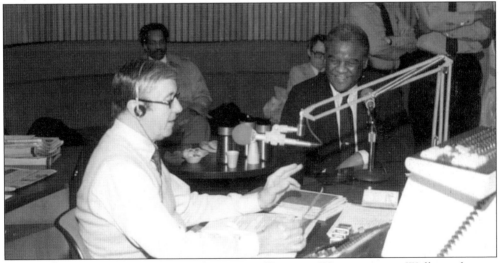

WALLY PHILLIPS WITH (THE LATE) MAYOR HAROLD WASHINGTON. Wally took over mornings on WGN radio in the mid 1960s amid anti-war protests, racial confrontations, urban riots, and political upheaval. At his peak, Wally commanded allegiance of half the morning radio listeners in the wider Chicagoland area. Mayor Harold Washington proclaimed December 5, 1987 to be Wally Phillips Day in Chicago, in recognition of his undying dedication to help mankind. He is enshrined in the Museum of Broadcast Communications Hall of Fame and was last heard on the radio dial at 850 AM, WAIT. He remembers, "I can assure you that my three kids, Holly, Todd, and Jennifer could never wait for the Marshall Field's windows to arrive in the usual spectacular [fashion]." (Photo courtesy of Wally Phillips.)

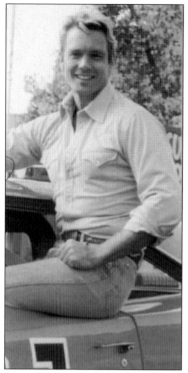

JOHN R. SCHNEIDER AND HIS CAR THE GENERAL LEE. One of the stars of the 1980s hit series *The Dukes of Hazzard*, Schneider is currently starring in *Smallville*. He is also a country music singer and recording star. He participated in the Chicago Christmas parade and titled his recollections of that experience "Christmas and the Birth of Passion."

"It was 1987. I was 27 years old, *The Dukes of Hazzard* was off the air after six and a half years, I was single and running all over this great country signing country music from a bus. Occasionally in your life you get to stop what you are doing and partake in something that sticks with you like a smell you can't scrub off. Something bigger than your present circumstance. That Christmas was just such an occasion. I was honored to be part of the Christmas Parade in Chicago, Illinois. The home of the first mile of America's Main Street, Route 66. Not only did I have a chance to help raise money for McDonald's Charity Christmas Parade, but birthed in me was a passion for travel that still burns within me this very day. My father, my mother, my children, and I all travel through time on 'The Mother Road' whenever we get the chance. We've spent birthdays there, gone out of our way to eat from places that exist solely because great aunt Millie's secret stew recipe is still the best in the land. This is a family tradition that was born in me on that day I spent time in the windy city, helping the kids and having the time of my life. Thank you, Chicago! And . . . Merry Christmas!" (Photo courtesy of John R. Schneider.)

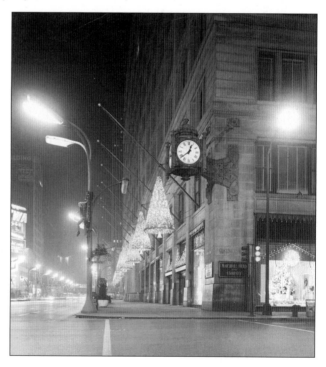

CORNER OF STATE AND WASHINGTON WITH ONE OF THE FAMOUS MARSHALL FIELD'S CLOCKS. (Photo courtesy of Marshall Field's.)

Kukla, Burr Tillstrom, and Ollie at Puppet Stage Set. Burr Tillstrom created the *Kukla, Fran and Ollie* children's show. A few of the Kuklapolitans, the characters on the show, were Madame Ouglepuss, Beulah Witch, Fletcher Rabbit, and Colonel Crackie. The show debuted on October 13, 1947 on WBKB-TV, and was originally called *Junior Jamboree*. Fran Allison began as a radio singer in Iowa in 1934 and moved to Chicago in 1937 where she appeared as Aunt Fanny on the Don McNeil radio and TV shows. *Kukla, Fran and Ollie* was one of the most beloved, unscripted, live children's daytime puppet shows. Burr Tillstrom's first puppet, Kukla, was created in 1936. The Russian ballerina, Tamara Toumanova, after seeing the puppet, bestowed Burr with the puppet's name, Kukla, which is the Russian word for doll. Hugh Downs was briefly an announcer for the show. Dick Tillstrom said of his brother, "It's a nice thing to be remembered!" (Photo courtesy of The Burr Tillstrom Copyright Trust, Richard W. Tillstrom, Trustee.)

Mother Goose Village Toy Display of 1925. (Photo courtesy of Marshall Field's.)

CHICAGO BLIZZARD OF 1967, LOOKING SOUTH FROM STATE AND RANDOLPH. Jim Tilmon, the long-time Chicago weatherman and former pilot for American Airlines, shared some beautiful sentiments about Chicago at Christmastime. He encourages travelers and visitors alike to come and see for themselves our town's Christmas spirit. He recalled being a volunteer bell ringer for the Salvation Army at State and Randolph. It was a cold, windy corner and he was doing his best to enjoy greeting all the people, until the cold started to creep into his toes and up through his body. Not wanting to disregard his commitments he asked to step away. Luckily Eddy Bauer was just around the corner on Wabash. All the heavy, winter clothes displayed looked great to him. Jim purchased almost everything; boots, undergarments, sweaters, hat, ear muffs, scarves, and a strong jacket. He returned dressed for the season and completed his commitment. The night before this happened he had advised his viewers that the weather was going to be rough and to bundle up if they were going outdoors. "If you dress properly, anyone can endure Chicago's weather. Cold is normal in Chicago winters."

Tilmon remembers as a child growing up in Oklahoma on each Christmas Eve the entire family made it back to the homestead to be with the large family. All the kids were instructed to go upstairs to bed and not come down until called. As it was in most homes, the piano was the center for entertainment and playing it filled his home with music. Come Christmas morning, his father's voice calling the children to come downstairs and playing Jingle Bells on the family piano were the best sounds in the world. All the kids marched down the stairs to see a beautiful Christmas tree, a room filled with the smiling faces of all the relatives, and presents all about the room. "It was beyond description." Santa always gave more than he asked for.

Jim thinks about Chicago at the Holidays as another gift (so to speak) under the tree. "The towns across America is where you can find a Christmas spirit. New York, L.A, Detroit, Milwaukee are cities, but at Christmas time Chicago becomes a town. This spirit penetrates the air. The camaraderie of the people who smile at each other—cab drivers are more helpful. It seems the colder it gets the nicer the people become. Chicago is unique." (Photo courtesy of Marshall Field's.)

PARADE WITH MARCHERS IN SCHOOL BAND. Harry Volkman, the longtime Chicago weatherman, shared these remarks with me. "It was an unusually warm December Saturday in Chicago about 1979 and thousands of citizens turned out for the annual State Street Christmas parade. Chicago's first woman mayor, Jane Byrne, in the front row of marchers, was especially happy for such a nice day, since she was elected, in part because of her promise to the voters that if she were elected, she would see that the city's streets would be plowed when it snowed. I was in the reviewing stand as she passed by. She saw me and immediately put her hands in a praying position, nodded her head towards me and mouthed the words, thank you . . . thank you! Probably I was the only one there that knew what and why she was saying that. As I was a long-standing weatherman in the city, she was thanking me for the beautiful parade weather. That was a wonderful gesture on her part and one of the most memorable days of my long career in Chicago television." (Photo courtesy of Marshall Field's.)

MARSHALL FIELD'S CHRISTMAS TOY WINDOW OF 1947. Before electricity and animated figures, this doll figure from the early 1900s (inset) of "Mary Had A Little Lamb" had to be hand wound each hour to show movement.

Clark Weber has been a Chicago radio voice since 1962. He was born in 1930 in Wauwatosa, a suburb of Milwaukee, Wisconsin. Being born during the depression, his family was filled with love and was not affected by the economic hard times. He remembered one year he asked Santa for a pair of snow skis. First thing Christmas morning his dad without any knowledge of any kind about skiing attempted to show Clark on the hill in front of their home how to ski. You guessed it—Dad broke a ski.

Clark and his wife Joan had four children. Each year after his radio show was over at 10 a.m., he would join his family and have breakfast under the tree at Marshall Field's. He still remembers it was one of the highlights of his family's traditions. His girls were all dressed up, wearing black patent leather shoes and white gloves. He said, "One especially bitter cold Christmas parade when working for WCFL radio in 1969 someone on my float brought along a bottle of brandy. I was encouraged to add some into my coffee to keep warm. It was the wrong thing to do. The president of The Chicago Federation of Labor, Bill Lee, saw us and wanted to call our general manager to fire us on the spot. Lucky for us, he was a forgiving man."

While working the morning radio show on WIND, in 1976 he established a Christmas tradition that he credits to Eddy Schwartz. Eddy gave him a book that year and suggested he read a particular poem on the air, "A Christmas Tea," by Ned Waldman. Ned was a Jewish boy who had a Polish nanny who introduced him to all the goodies of the traditional Christmas. The story poem itself was said to be sent to him by a high school teacher who wrote the story for his Minnesota church's 100th anniversary. Ned thought about his nanny and in her memory published it.

"A Christmas Tea" is the story of a man who one Christmas goes back and visits his old and ailing aunt who he hadn't seen in years. To his amazement he discovered she had decorated her entire home with all his old childhood hand-made papers, drawings, projects, cards, and toys. Everything he had drawn, made or created and gave to her, she had kept safe all these years. As tears came into his eyes, he was a child once more and reliving that special time from years gone by when his aunt was as young and as healthy as he remembered her to be. Well, the switchboard in the radio studios lit up like a Christmas tree itself with all kinds of 'thank you' and 'keep it up' calls, and Clark did. People still stop him and tell him how they enjoyed that poem. (Photo courtesy of Marshall Field's, inset photo by R.P. Ledermann.)

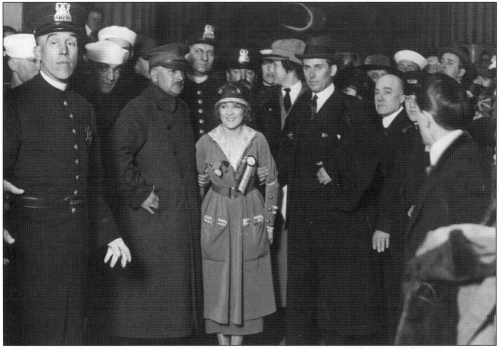

MARY PICKFORD VISITS CHICAGO IN 1918. (Photo Courtesy of Marshall Field's.)

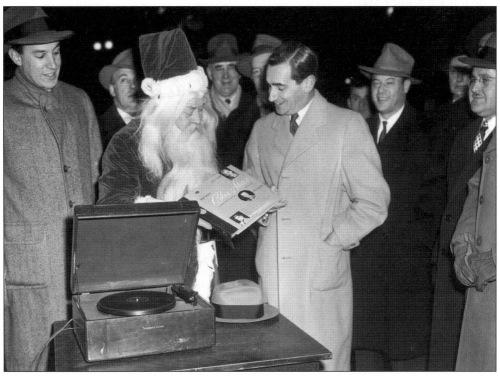

IRVING BERLIN IN CHICAGO. Berlin is pictured here in 1946 with Santa. He was promoting his new hit record, "Blue Skies." (Photo Courtesy of The Greater State Street Council.)

WALKING UP STATE STREET IN 1948. Pictured are Mary Fullner, P.R. director and Council chairperson of the Greater State Street Council; Marge Elgren, P.R. of the Palmer House; Mary Neimo, cashier of the Republic Building Restaurant; and guest Maurice Chevalier. (Photo by Leonard Bass, used courtesy of The Greater State Street Council.)

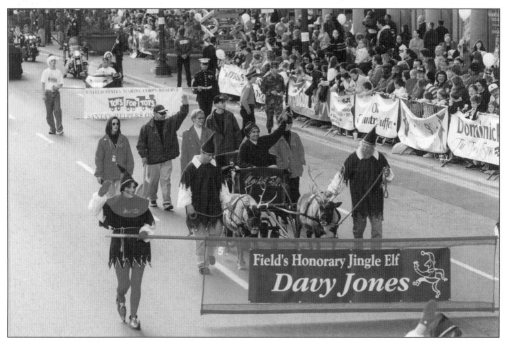

DAVY JONES OF "THE MONKEYS" ON MICHIGAN AVENUE IN THE JINGLE ELF PARADE OF 1997. (Photo courtesy of Marshall Field's.)

Three
CARSON PIRIE SCOTT &
COMPANY DEPARTMENT
STORE

Let us once again visit Carson's, for there is much more to see than I had room to convey in my first book, *Christmas on State Street: 1940s and Beyond.* Carson's was founded in 1854 by Samuel Carson and John T. Pirie, who were immigrants from northern Ireland. The chain of small stores was founded in Amboy, Illinois and expanded through the state to Mendota, Polo, Galena, and Sterling, before opening the first Chicago store in 1864 near State and Lake. The retail store became Carson, Pirie, Scott and Company in 1890, when John E. Scott became a partner. They moved into the Louis Sullivan designed flagship location on State Street in 1904. The building they moved in to, formerly the Schlesinger and Meyer building, was in the center of State Street's retail district at State and Madison.

The spectacular Louis Sullivan ornamental iron work, which is even today one of Chicago's most impressive facades, sets it apart from the other buildings on this famous street. Entering the famed vestibule (the rotunda was restored in 1979) at the corner of State and Madison fills one with a feeling of grandeur, which in the Christmas season is an extra highlight.

In the *Sunday Chicago Tribune* of April 24, 1994 (section 13) the *Tribune* architecture critic, Blair Kamin, said: "No State Street department store, not even Marshall Field's, is more important in the history of architecture." He goes on to say: "The Carson, Pirie, Scott and Company store was one of Louis Sullivan's greatest designs, perhaps his greatest, an epoch-defining image that transformed the static rationality of its structural steel frame into a superbly fluid composition that welcomes the shopper with an intricate veil of cast iron ornament." And I'm inclined to agree with him.

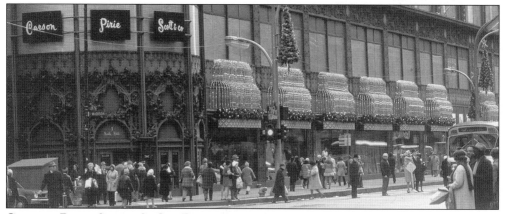

CARSON, PIRIE, SCOTT & CO. DEPARTMENT STORE—CORNER OF STATE AND MADISON. (Photo courtesy of Carson, Pirie, Scott & Co.)

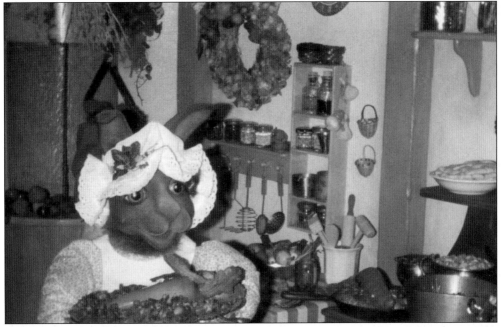

SMALL ANIMALS OF THE FOREST PREPARE FOR CHRISTMAS IN CARSON'S WINDOWS. The amazing Christmas windows have told many stories through the years, including *Amahl and the Night Visitors*, *A Christmas Carol*, *The Nutcracker*, and those heart-warming small animals of the forest seen here. (Photo by R.P. Ledermann.)

MRS. BUNNY RABBIT PREPARES HER HOLIDAY MEAL. (Photo by R.P. Ledermann.)

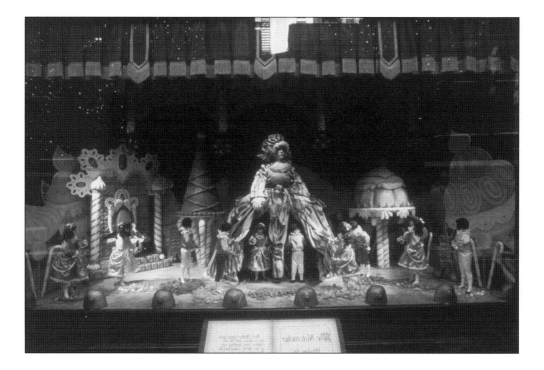

THESE PICTURES SHOW CARSON, PIRIE, SCOTT & COMPANY NUTCRACKER CHRISTMAS WINDOWS OF THE 1980S. (Photo courtesy of Carson, Pirie, Scott & Co.)

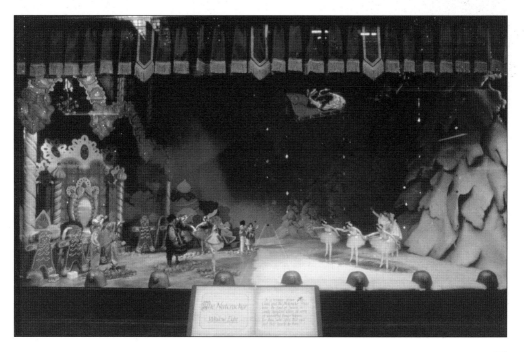

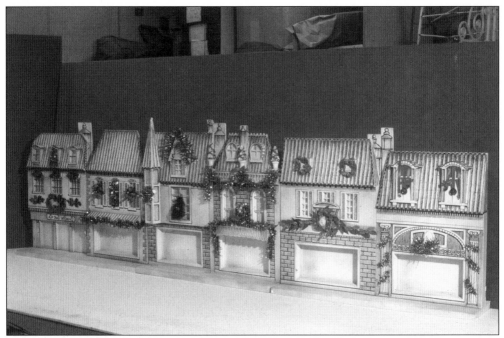

SMALL MODEL OF CHRISTMAS SHOPS FACADES USED IN THE 1960S TO FRAME THE CHRISTMAS WINDOWS OF THE CARSON, PIRIE, SCOTT STORE. (Photo courtesy of Carson, Pirie, Scott & Co.)

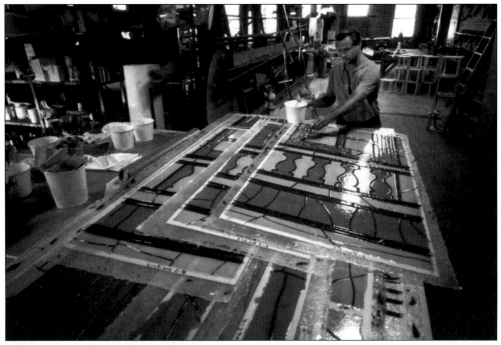

WORKING ON THE CARSON, PIRIE, SCOTT CHRISTMAS WINDOWS IN THE 1960S. The workmen are preparing stained glass facades that would frame the windows, making them each look like storefronts. (Photo courtesy of Carson, Pirie, Scott & Co.)

CRAFTSMAN INSTALLING FAÇADES ON CHRISTMAS WINDOW DISPLAYS AT CARSON'S. (Photo courtesy of Carson, Pirie, Scott & Co.)

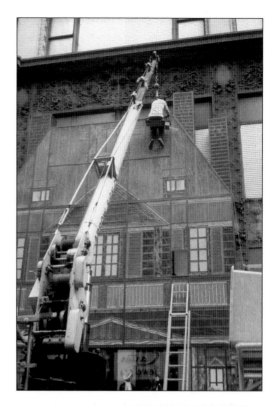

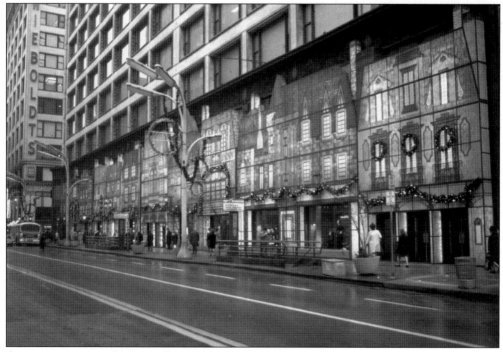

COMPLETED SET OF STAINED GLASS CHRISTMAS SHOPS FRAMING THE CHRISTMAS WINDOWS OF CARSON'S. (Photo courtesy of Carson, Pirie, Scott & Co.)

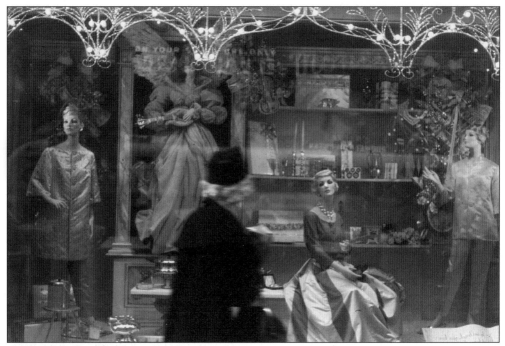

A Shopper Admires a Carson's Christmas Window Featuring Ladies Accessories, c.1970s. (Photo courtesy of Carson, Pirie, Scott & Co.)

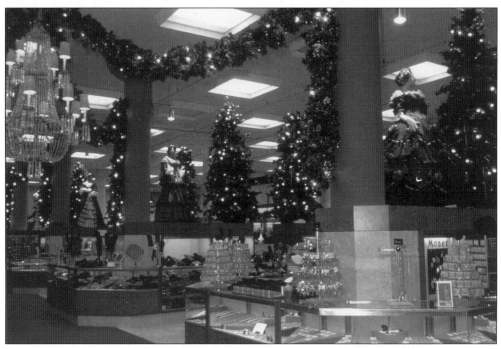

Interior of Carson's Main Floor, Decked out for the Holidays. (Photo courtesy of Carson, Pirie, Scott & Co.)

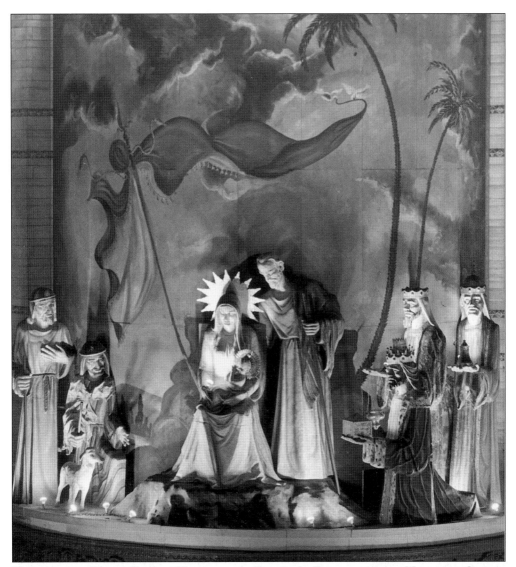

HIGH ABOVE STATE STREET NESTLED ON CARSON'S ROTUNDA, THE NATIVITY GREETS SHOPPERS. (Photo courtesy of Carson, Pirie, Scott & Co.)

The following pages show the 1950s window per window adaptation of *Amahl and the Night Visitors*, from Gian Carlo Menotti's opera, which was written on a Christmas theme, and was the first opera written expressly for TV. The two hour production by the NBC Opera Company first appeared on Christmas Eve 1951. In the 1953 production, presented by *The Hallmark Hall of Fame* series, was the first sponsored show to be televised in color. The story is about Amahl, a small handicapped shepherd boy, and his mother. They are visited by the Magi—Balthazar, Melchior, and Kaspar. The Magi were on a quest to follow the Star of Bethlehem to find the Christ Child. The kings stay the night, but during the night, Amahl's mother is tempted and tries to steal some gold from the kings. She is caught in the act by Melchior, who suggests she keep the gold because the child they will find will rule his kingdom with love not riches. Amahl's mother gives the gold back, wishing she had something of her own to give. Amahl then offers his crutch as a gift and suddenly is able to walk. Amahl then travels with the Magi to give his gift to the Christ Child.

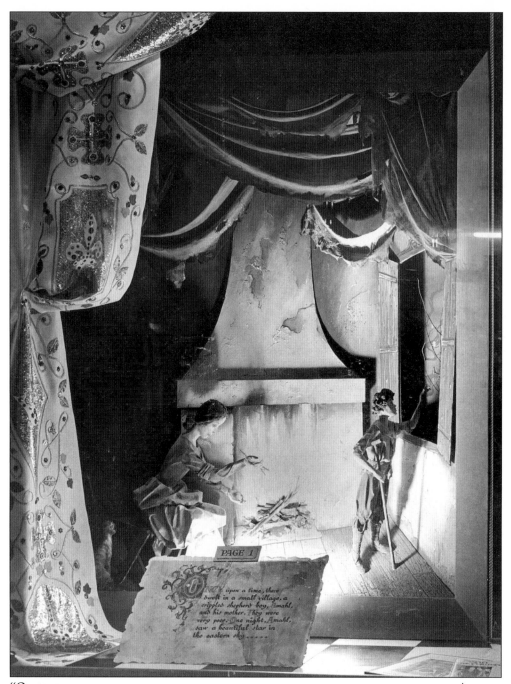

"ONCE UPON A TIME THERE DWELT IN A SMALL VILLAGE, A CRIPPLED SHEPHERD BOY, AMAHL, AND HIS MOTHER. THEY WERE VERY POOR. ONE NIGHT, AMAHL SAW A BEAUTIFUL STAR IN THE EASTERN SKY. . . ." (Photo by Idaka-Chicago, used courtesy of Carson, Pirie, Scott & Co.)

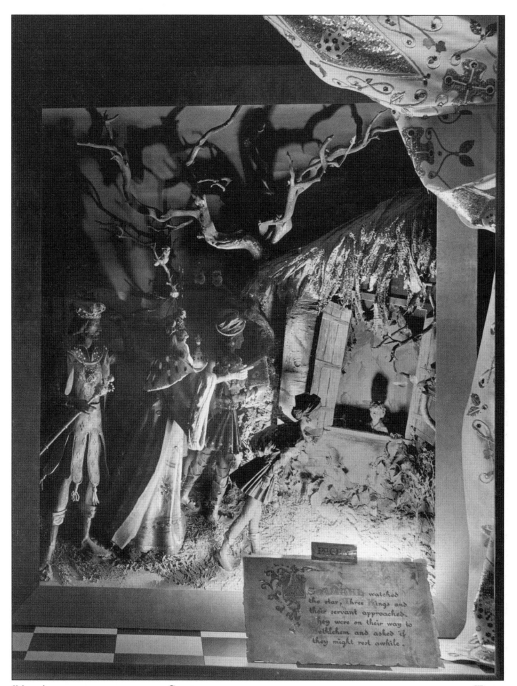

"As Amahl watches the Star, three kings and their servants approach. They were on their way to Bethlehem and asked if they might rest awhile." (Photo by Idaka-Chicago, used courtesy of Carson, Pirie, Scott & Co.)

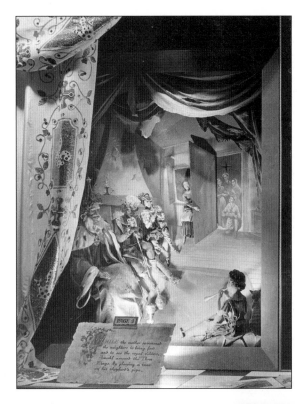

"While the mother summons the neighbor to bring food and to see the royal visitors, Amahl amuses the Three Kings by playing a tune on his shepherd's pipe." (Photo by Idaka-Chicago, used courtesy of Carson, Pirie, Scott & Co.)

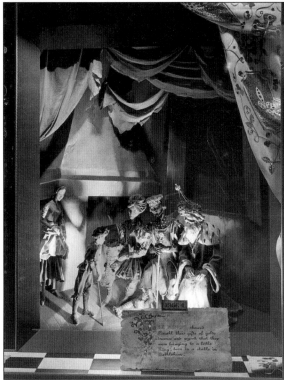

"The Kings showed Amahl their gifts of gold, incense and myrrh that they were bringing to a little King, born in a stable in Bethlehem." (Photo by Idaka-Chicago, used courtesy of Carson, Pirie, Scott & Co.)

" 'I HAVE NO JEWELS, INCENSE OR MYRRH TO SEND THE NEWBORN KING,' SAID AMAHL, 'WILL YOU TAKE MY CRUTCH AS A GIFT?' AND, LO, AMAHL WAS NO LONGER A CRIPPLE!" (Photo by Idaka-Chicago, used courtesy of Carson, Pirie, Scott & Co.)

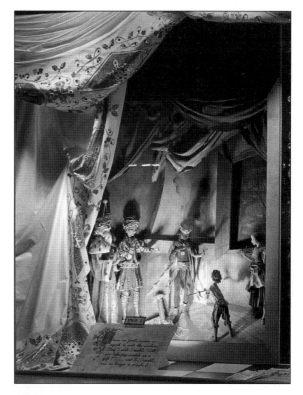

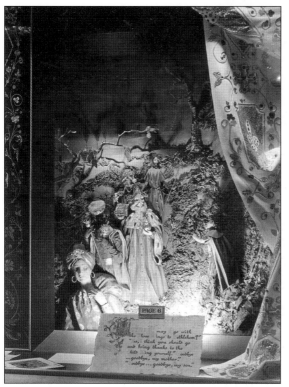

" 'MOTHER, MAY I GO WITH THE THREE KINGS TO BETHLEHEM?' 'YES, I THINK YOU SHOULD GO AND BRING THANKS TO THE CHILD KING HIMSELF.' 'GOODBYE . . . GOODBYE, MY MOTHER.' 'GOODBYE . . . GOODBYE, MY SON.' " (Photo by Idaka-Chicago, used courtesy of Carson, Pirie, Scott & Co.)

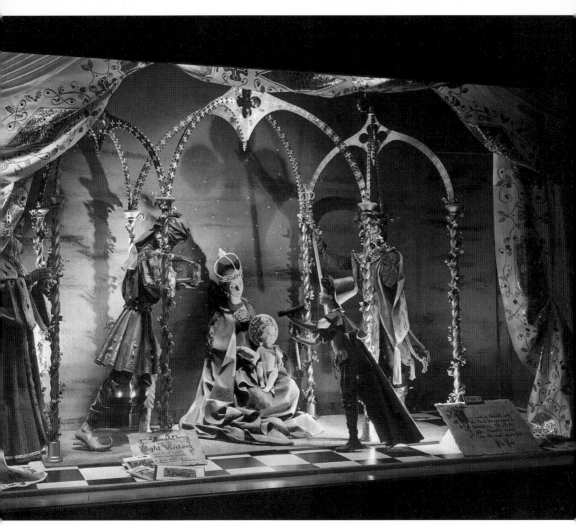

"AND SO AMAHL AND THE THREE KINGS WENT TO BETHLEHEM. OF ALL THE GIFTS AMAHL'S CRUTCH WAS THE MOST WONDERFUL." (Photo by Idaka-Chicago, used courtesy of Carson, Pirie, Scott & Co.)

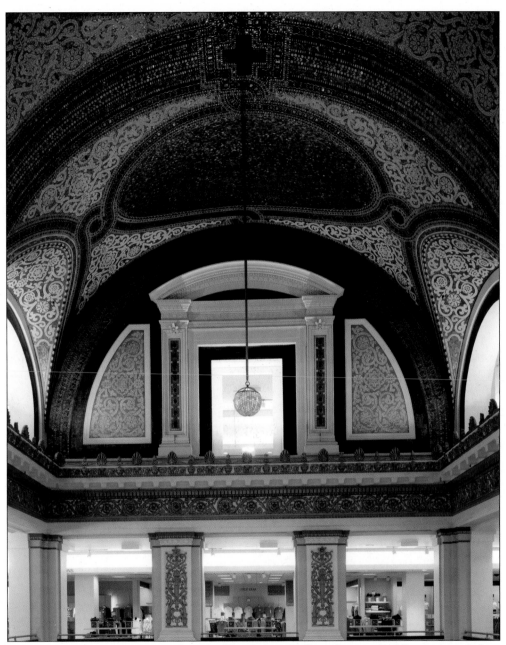

TIFFANY DOME AT MARSHALL FIELD'S. The famous Tiffany dome at Field's was unveiled on September 30, 1907. Suspended from the ceiling is one of the Tiffany leaded light fixtures. (Photo courtesy of Marshall Field's.)

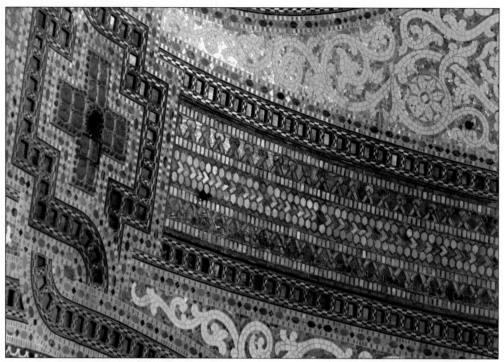

TIFFANY DOME DETAIL. The dome contains 1.6 million pieces of multi-colored Favril glass, and it took 50 artisans a year and a half to install. (Photo courtesy of Marshall Field's.)

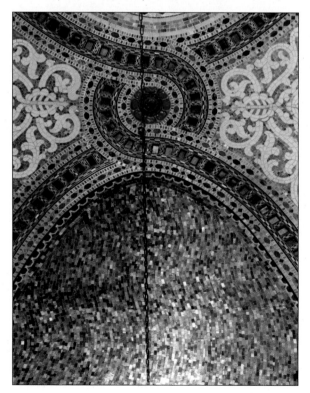

HANDMADE ORNAMENTS, MARSHALL FIELD'S, 1970S. (Photo courtesy R.P. Ledermann.)

VERTICAL VIEW OF THE DOME. This detailed close-up shows how the dome looks from 385 feet above the main aisle. (Photo courtesy of Marshall Field's.)

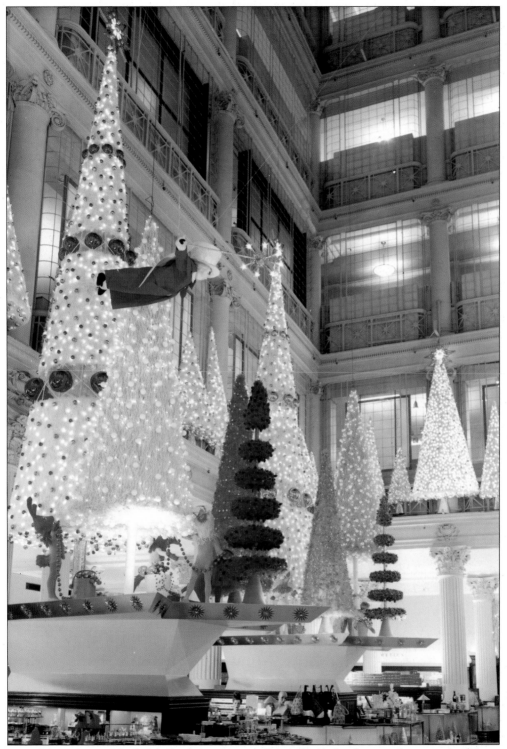

1961 MAIN AISLE. Uncle Mistletoe can be seen flying above the decorated main aisle. (Photo courtesy of Marshall Field's.)

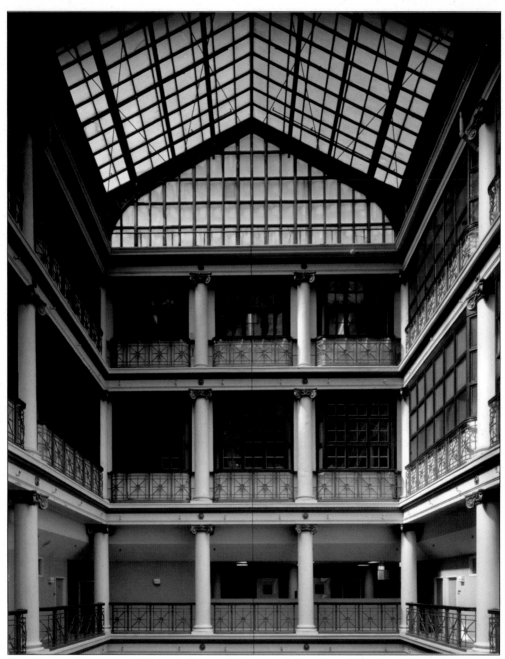

SKY LIGHT ABOVE THE NORTH LIGHT WELL AT MARSHALL FIELD'S. (Photo courtesy of Marshall Field's.)

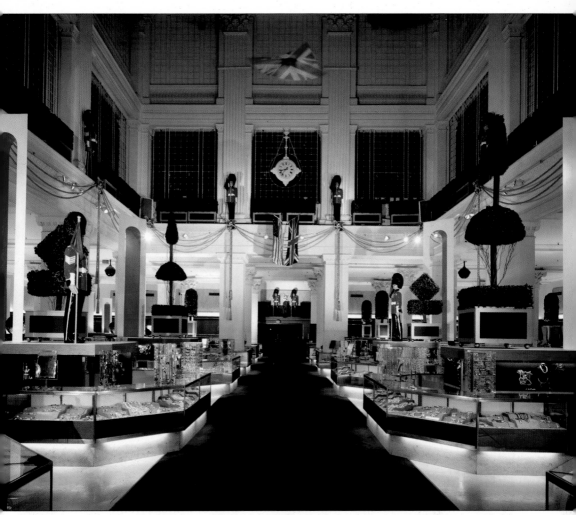

MAIN AISLE, 1968. The aisle was decorated for the English promotion, "The Eagle and the Crown." This promotion carried into the holidays. Note the Palace Guards surrounding the main floor. (Photo courtesy of Marshall Field's.)

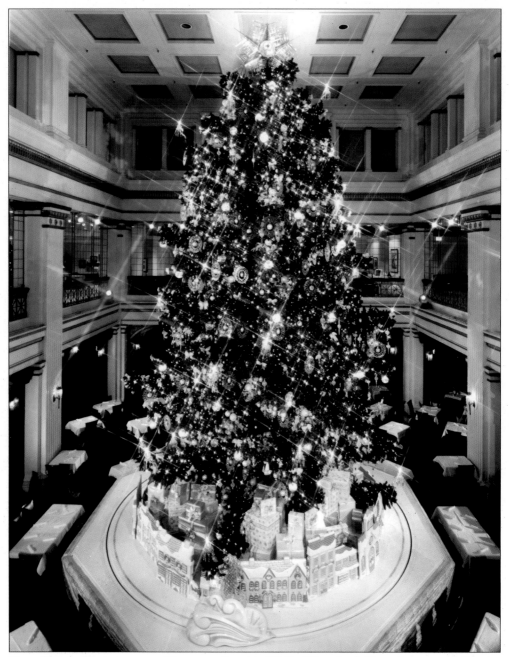

THE GREAT TREE IN THE WALNUT ROOM, 2003. Waterford Crystal was used for the ornaments in 2003. This was a new tree, and the second artificial one used in the Walnut Room, which switched to artificial trees in the early 1960s. (Photo courtesy of Marshall Field's.)

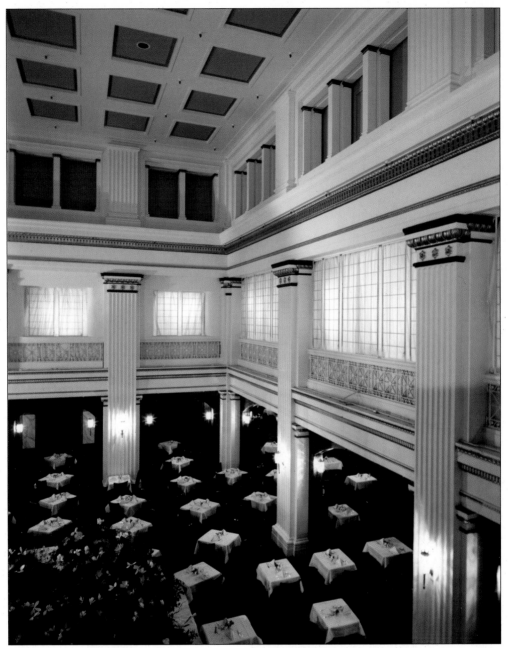

WALNUT ROOM IN 1988. (Photo courtesy of Marshall Field's.)

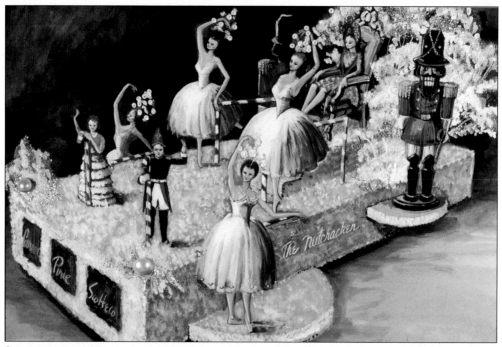

SKETCH OF THE NUTCRACKER CHRISTMAS FLOAT. This float was sponsored by Carson, Pirie, Scott & Co. (Photo courtesy of Carson, Pirie, Scott & Co.)

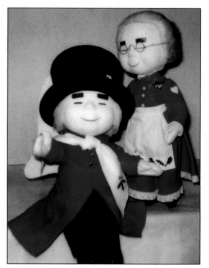

RUBBER MOLD FIGURES OF UNCLE MISTLETOE AND AUNT HOLLY. (Photo courtesy of Marshall Field's.)

MARSHALL FIELD'S MAIN AISLE IN THE 1990s. (Photo courtesy of R.P. Ledermann.)

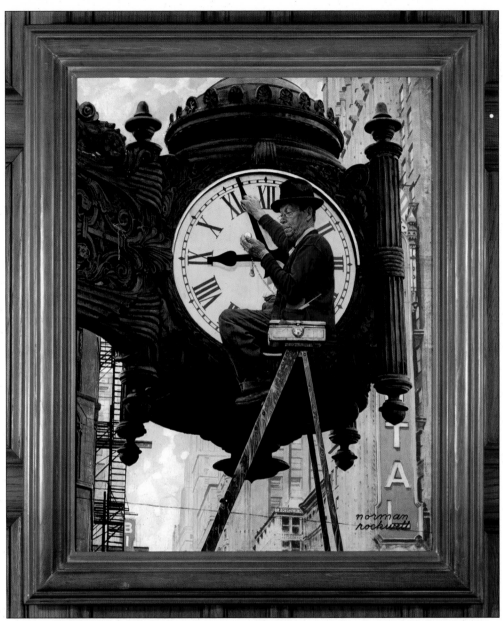

NORMAN ROCKWELL'S *Clock Mender.* This 1945 painting by Norman Rockwell can be seen on the seventh floor of Marshall Field's State Street store. (Photo courtesy of Marshall Field's.)

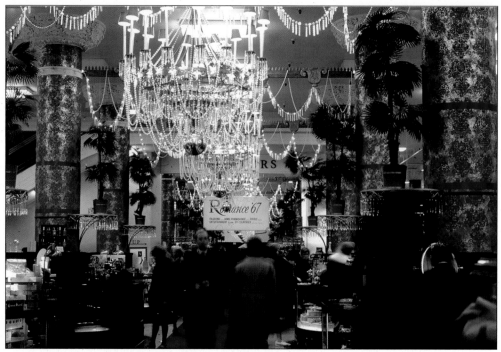

MAIN FLOOR OF CARSON, PIRIE, SCOTT & CO. ON STATE STREET. (Photo courtesy of Carson, Pirie, Scott & Co.)

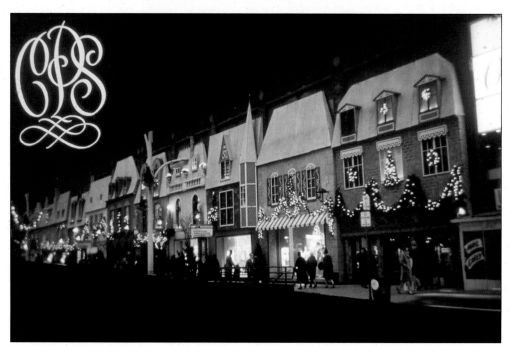

CHRISTMAS WINDOW FAÇADES AT CARSON, PIRIE, SCOTT & CO. These beautiful, elaborate façades framed the Christmas windows at the department store in the 1960s. (Photo courtesy of Carson, Pirie, Scott & Co.)

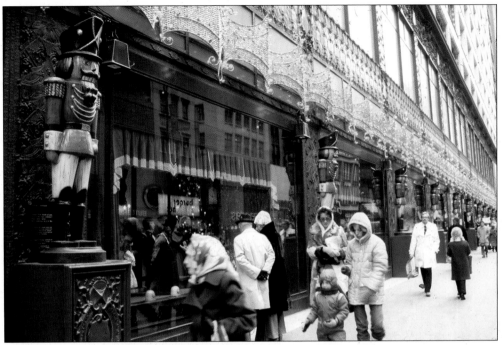

SHOPPING ON STATE STREET. These Christmas shoppers are admiring the Nutcracker windows at Carson, Pirie, Scott & Co. in the 1980s. Note the giant Nutcracker on the left. (Photo courtesy of Carson, Pirie, Scott & Co.)

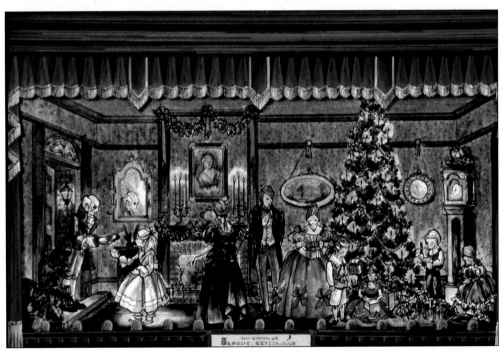

SKETCH OF NUTCRACKER WINDOW. This is a sketch of the first Nutcracker window for Carson's. It shows the family parlor. (Photo courtesy of Carson, Pirie, Scott & Co.)

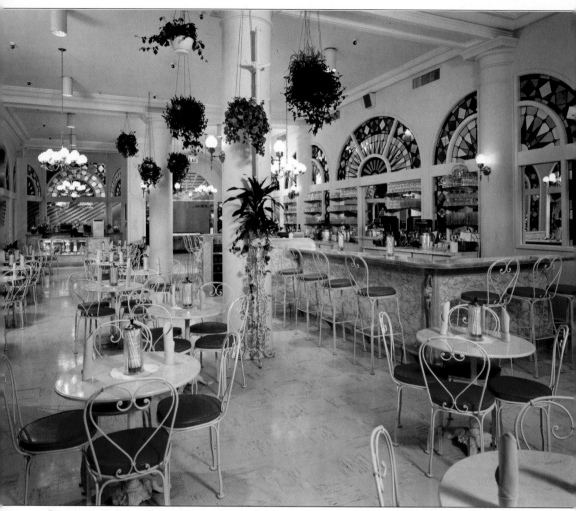

CRYSTAL PALACE ICE CREAM SHOP. This could be found in 1975 on the third floor at Marshall Field's. It was like visiting the old-time ice cream parlors of days gone by. (Photo courtesy of Marshall Field's.)

HANDMADE ORNAMENTS FOR THE GREAT TREE AT MARSHALL FIELD'S, 1970S. (Photo courtesy of R.P. Ledermann.)

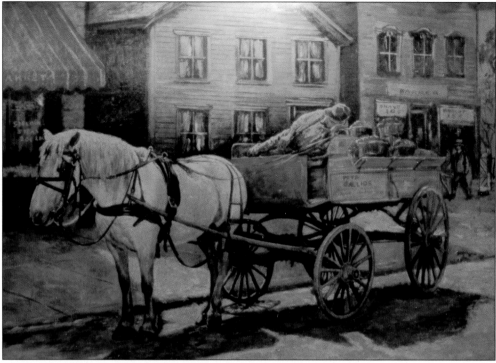

HORSE AND WAGON CART. This oil painting is owned by the Gallios family and can be seen in Miller's Pub Restaurant. It depicts their father's horse and wagon cart on the streets of Chicago. (Photo courtesy of Miller's Pub.)

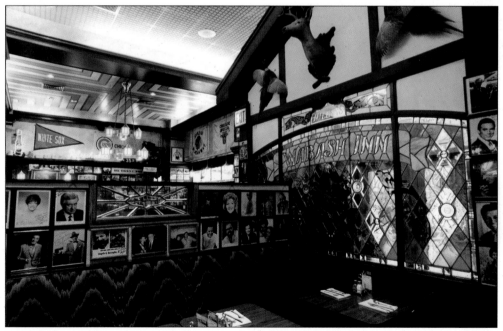

INTERIOR OF MILLER'S PUB. This interior shot of the pub shows the beautiful stained glass paneling and the wall of celebrity photos. (Photo courtesy of Miller's Pub.)

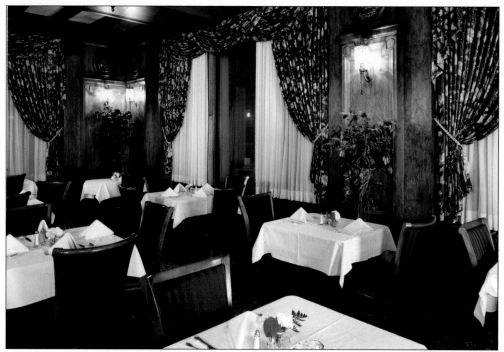

SOUTHWEST CORNER OF THE WALNUT ROOM. This 1988 photo shows some of the grandeur of the Walnut Room Restaurant on the seventh floor of Marshall Field's. Note the Circassian Walnut paneling and crystal wall sconces. (Photo courtesy of Marshall Field's.)

COZY CLOUD COTTAGE. This was the 1987 home of Uncle Mistletoe and Aunt Holly at Marshall Field's. The inset shows the rubber mold figures of the two characters. (Photo courtesy of Marshall Field's.)

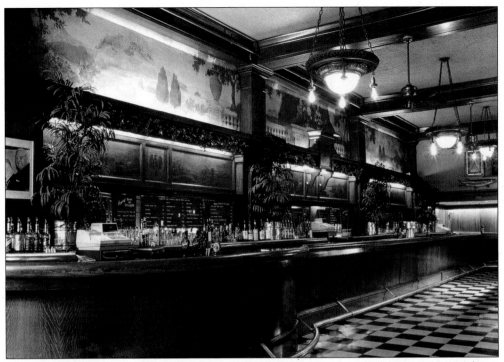

BERGHOFF RESTAURANT. This 1990 photograph shows the famous stand-up bar at the restaurant, along with the hand-painted murals and vintage light fixtures. (Photo courtesy of The Berghoff.)

THE BERGHOFF'S MAIN DINING ROOM. The elegant main dining room is seen here in 1990. Note the highly polished tables and chairs, the wood paneling, and the stained glass windows. (Photo courtesy of The Berghoff.)

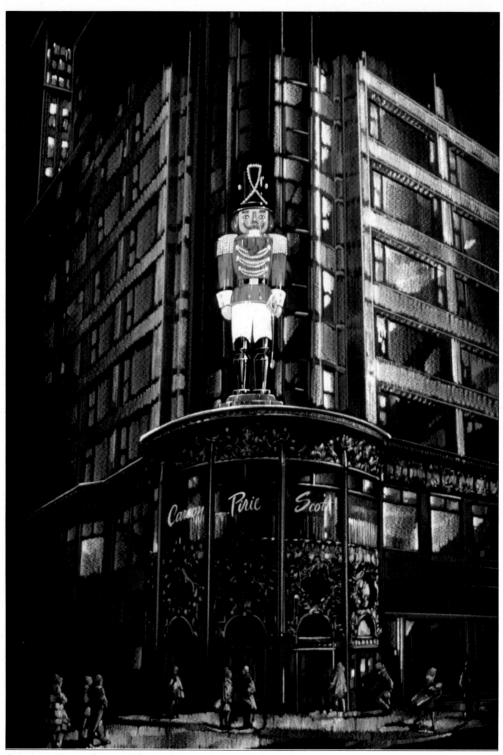

CARSON, PIRIE, SCOTT. This artist's rendering of the main entrance at State and Madison clearly shows the grand Louis Sullivan iron work. (Photo courtesy of Carson, Pirie, Scott & Co.)

Four
THE BERGHOFF
RESTAURANT

After the holiday parade, with a chill built up in your bones, there is nothing like warming yourself up with a fine lunch at the oldest restaurant in Chicago, Berghoff's. It achieved this distinction when founder and owner Herman Berghoff had the wonderful idea to come to The Chicago Colombian Exposition of 1893. He set up along side the Midway (Saloon), a small beer stand catering to the fair goers. Herman Joseph Berghoff, an immigrant to America in 1870 from Dortmund, Germany, began brewing Berghoff beer in Fort Wayne, Indiana in 1887 as a family enterprise with his three brothers, Henry, Hubert, and Gustav. Inspired by his success at the fair, Herman opened the Berghoff Café in 1898. He served a Dormunder style beer. It was originally located at the corner of State and Adams, just one door down from its present location, which it moved to in 1914. The bar sold beer for a nickel and offered sandwiches for free.

The interior at the turn of the century, with bold, warm, woodwork, beautiful stained glass, and white and black tiled checkered floors throughout the main level dining rooms was like a welcoming old friend. Original brass light fixtures hang from the high ceilings, and hand-crafted painted murals of "Old Chicago" overlook the famous standup bar. The Berghoff's 75-foot standup bar was the last all male bar in Chicago (until 1969). Enjoying a stein of its 100 year old full-bodied malt beer, along with a selection from their delicious German menu is a real mouth watering treat.

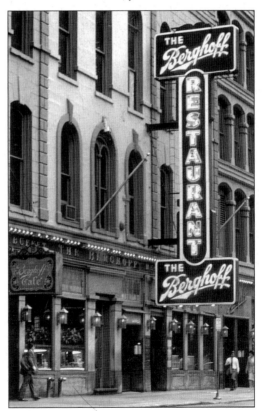

THE FAMOUS BERGHOFF RESTAURANT, OLDEST IN THE CITY. This photo was taken of the restaurant at 17 W. Adams Street in 1990. (Photo courtesy of the Berghoff.)

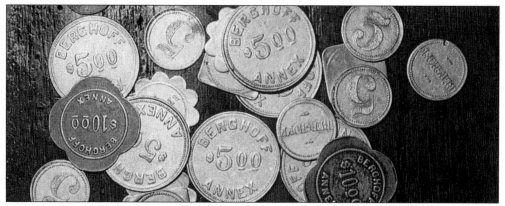

THE BERGHOFF COINS. When the restaurant opened in 1897, several traditions followed Herman Joseph Berghoff from Germany to America. In Europe, waiters worked more as independent contractors and purchased coins from the restaurant at the beginning of their shift. These coins were used to purchase food and beverages from the house. Throughout the day when they ordered food from the kitchen, they would pick up their food, and then pay the cashier with metal coins that were created by the restaurant. They used metal coins because the waiters were usually carrying large amounts of food on one arm and could reach in their aprons and count out the coins more easily. At the time, these coins were in denominations of 5 cents, 10 cents, 25 cents, and 1 dollar. This system was suspended in 1980 when The Berghoff moved to using computers to assist in serving the guest in a more efficient manner. Anyone who ever visited The Berghoff before 1980 distinctly remembers the constant clink of their special currency. (Photo courtesy of The Berghoff.)

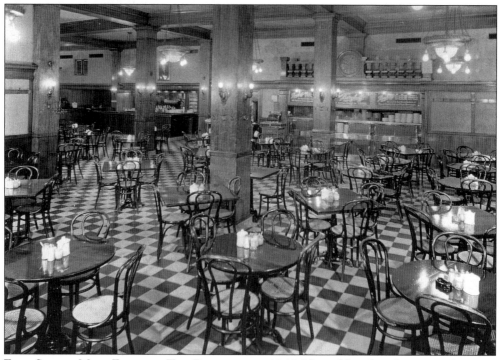

EAST SIDE OF MAIN FLOOR OF THE BERGHOFF IN 1940. Note old wicker chair seats that were in use at the time. (Photo courtesy of The Berghoff.)

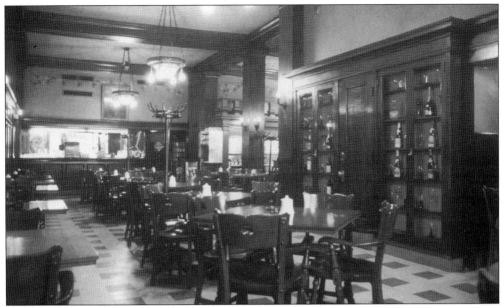

MAIN FLOOR OF THE EAST SIDE OF THE BERGHOFF IN 1950. Note the change in furniture. (Photo courtesy of The Berghoff.)

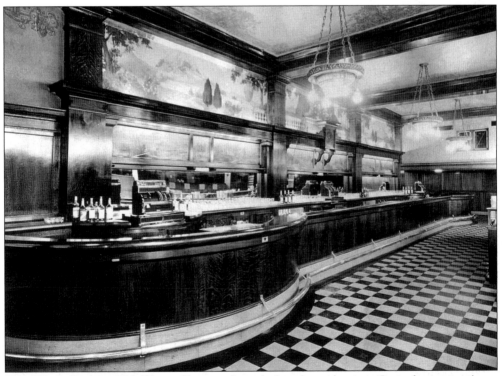

THE MEN'S GRILL, 1950. The grill was exclusively for men at the time. See color section (page 79) for photo of the renovated bar with a new foot rest and new cash registers. Until 1969 this was one of the last all male bars in the city. Today ladies are always welcomed. (Photo courtesy of The Berghoff.)

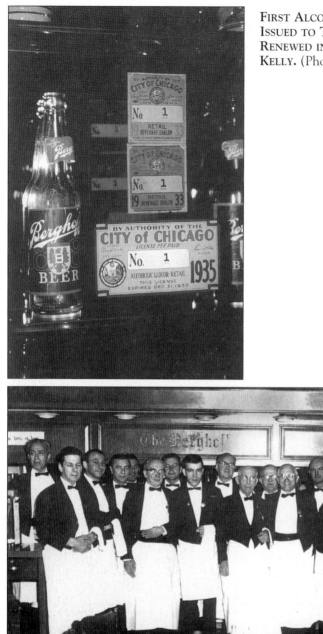

FIRST ALCOHOLIC LIQUOR RETAIL LICENSE ISSUED TO THE BERGHOFF IN 1933, RENEWED IN 1935 BY MAYOR EDWARD J. KELLY. (Photo courtesy of The Berghoff.)

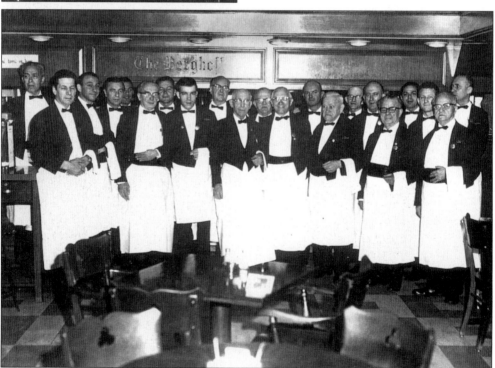

STAFF OF ALL MALE WAITERS IN 1950. The waiters were prepared to serve the customers, with clean white aprons and drip towels over their arms. (Photo courtesy of The Berghoff.)

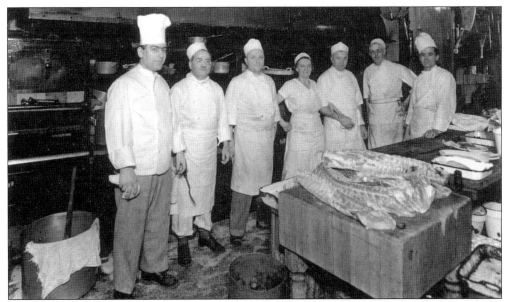

THE BERGHOFF BUTCHER STAFF AND HEAD CHEFS IN THE 1930S. They prided themselves on using only the very freshest meats and seafood, which were prepared fresh to order daily. (Photo courtesy of The Berghoff.)

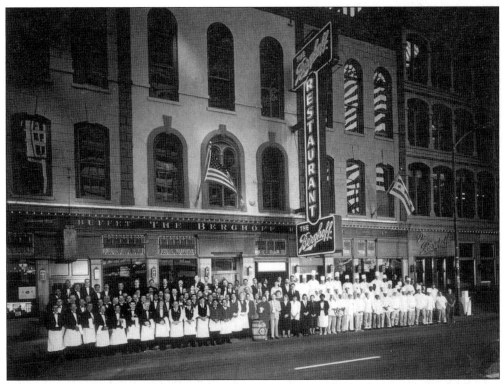

THE COMPLETE STAFF OF THE BERGHOFF RESTAURANT IN 1990. Everyone gathered for this photograph, including owners, management, cooks, waiters, bartenders, hostesses, bus boys, and kitchen helpers. (Photo courtesy of The Berghoff.)

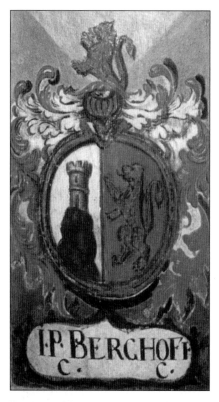

FAMILY CREST OF BERGHOFF. The Berghoff crest was photographed in the sanctuary, and also in the museum, of the Cathedral in the town of Limburg, on the Lahn River in Germany. The Crest dates from before 1750 and consists of an oval shield, divided in half vertically into a blue and a red field. On the blue field on the left there appears a brown hilltop upon which rests a tower. Against the red field on the right of the oval shield, a lion is depicted standing on its hind legs with its fore paws resting on the central divider. Mounted on the top of the shield is a helmet surrounded by oak leaves. A small lion in profile is seated on the top of the helmet. (Picture of family crest courtesy of The Berghoff.)

FOUNDER HERMAN JOSEPH BERGHOFF IN 1933 HOLDING HIS RETAIL BEVERAGE DEALER LICENSE. Founder Herman Berghoff enjoyed displaying the first liquor license issued to him in Chicago the day after Prohibition ended in 1933. Since Prohibition days are long gone, it's nice to know they still serve their own private stock of 10 year old Kentucky Bourbon. Today Herman's succeeding third and fourth generations still keep this old, gracious restaurant just as beautiful as it always was. The Berghoff has become a favorite destination for generations of diners from Chicago and around the world. The holiday decorations, the beautiful full Christmas tree in the main dining room, and the entire restaurant aura, magically transforms ones thoughts at Christmas time.(Photo courtesy of The Berghoff.)

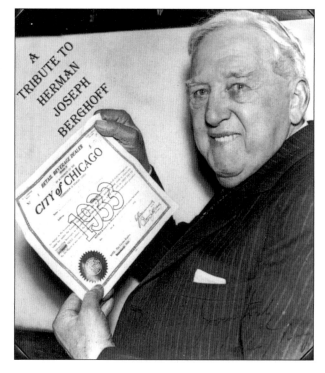

Five
MILLER'S PUB
RESTAURANT

Another great place to have a delicious meal or an old fashioned "Tom and Jerry" after a Christmas parade is Miller's Pub. The December 5, 2003 edition of the *Wall Street Journal* reported: "The Miller's Pub in Chicago as one of the most underrated restaurants." Dan and George Miller began their Chicago establishment in 1935 at 23 E. Adams. Their family restaurant was started with a pleasant and homey atmosphere. Then on February 1, 1950 the Gallios brothers, Peter, Nick, Jim, and Van took over the business. All four brothers had come home as veterans of World War II. Throughout the years they opened and closed other restaurants within the area, including The Wabash Inn and Vannies.

After a fire in the original Miller's Pub on Adams in the late 1980s, they decided in 1988 to open a new Miller's Pub at 134 South Wabash. This was the old Vannies location. They had managed to save the fine paintings and some of the fixtures that had adorned the original restaurant. The brothers had the paintings restored and the fixtures refurbished after the fire. While still another brother, John, went into dentistry, the other four brothers remained steadfast and, as the song goes, they dusted themselves off and started over again. Brother Jimmy was always the public relations point person as the good-will ambassador of the family. He was a great friend and pal of Ed McCaskey, who married Virginia Hallas, daughter of the famed George Hallas. Both Jimmy and Ed McCaskey had gotten jobs as Andy Frain ushers after World War II.

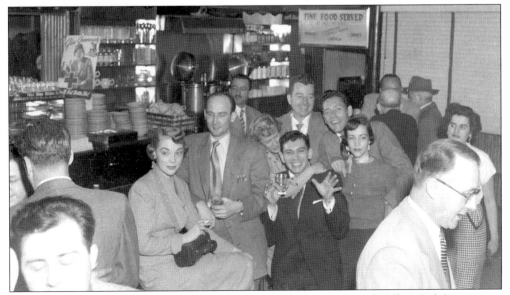

MILLER'S PUB CUSTOMERS IN THE EARLY 1950S. (Photo courtesy of Miller's Pub.)

MILLER'S PUB POST CARD. This card show the four Miller brothers that went into the restaurant business. From left to right, they are Van, Jimmy, Pete, and Nick. Jimmy made it his business to find out who was coming to town. After their performances in the Empire Room of the Palmer House Hilton, celebrities would go to Miller's for a meal or nightcap. Along with famous sports stars, movie stars, and politicians, famous Chicagoans like the late Bill Veeck and Irv Kupcinet also were regulars at the Pub. The good food and spirits continue to make Miller's Pub a great success. Their specialties are barbecue baby back ribs, steaks, chops, and seafood. (Photo courtesy of Miller's Pub.)

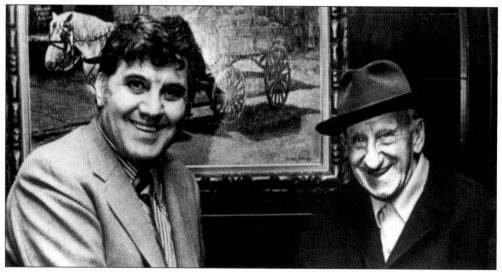

JIMMY GALLIOS WITH JIMMY DURANTE. Upon entering the restaurant you immediately notice the striking wood paneling and the stained glass partitions. Beautiful oil paintings grace all the rooms. The most famous and recognized painting, partly shown here, serves as a greeting. It is a painting of a horse and cart on the streets of Chicago, a fond memory of the horse and cart used by the Miller brother's father, Harry, when he first came to Chicago. It was painted by Alex Smith from the Art Institute of Chicago in the 1950s. He used an old family photo as his guide. In helping their father, the Miller's would often go as far as Oak Park selling fruit. On their way home if they happened to come upon a piece of old junk, iron or metal, they would put it into the cart to be sold later as scrap metal. It was truly a family working together that led to their success in life. This painting reminded them of their good fortune. (Photo courtesy of Miller's Pub.)

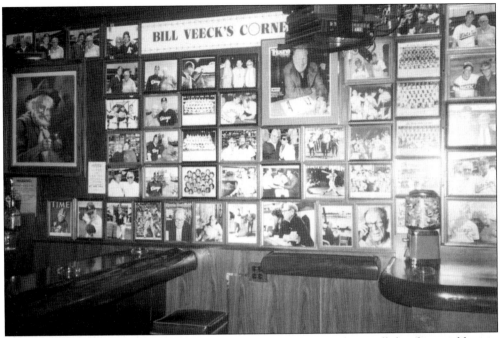

BILL VEECK'S CORNER AT MILLER'S PUB. Looking about, one notices all the photos of famous celebrities as well as politician that not only line the walls, but can be seen displayed in the windows. Van Gallios speaks with fondness of the stories of his family's old friend, Bill Veeck. As you approach the bar, you notice the wall which has a sign that reads 'Veeck's Corner' in honor of the famous baseball owner. Veeck had a terrific sense of humor and a universal and unmistakable appeal to baseball fans. Van remembers Veeck would love to come in and sit at the same bar stool so he could converse with the other bar patrons about sports, politics, and the hot topics of the day. Bill enjoyed just talking to people and remained good friends with the Gallios family until his death. (Photo courtesy of Miller's Pub.)

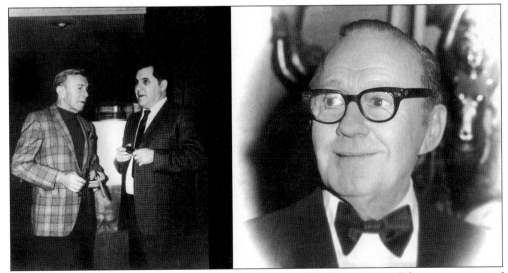

(*Left*) **JIMMY GALLIOS WITH GEORGE BURNS.** (*Right*) **JACK BENNY.** (Photos courtesy of Miller's Pub.)

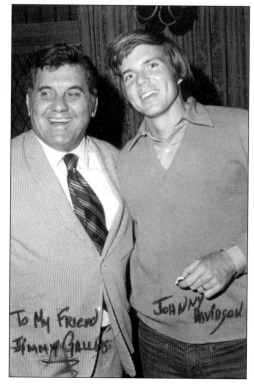

(Above *left*) JIMMY GALLIOS WITH "PAPA BEAR" GEORGE HALAS. The Miller's have great memories of their celebrity patrons. Jimmy Durante would always put in a special order for figs and ice cream. Jack Benny always left an extra 39 cents above his normal tip, in honor of his ever being 39 years old. (Photo courtesy of Miller's Pub.)

(Above *right*) JIMMY GALLIOS WITH JOHN DAVIDSON. Other memories include seeing the late Milton Berle do card tricks and tell jokes, and that the drummer Buddy Rich loved Miller's coleslaw so much he never left without taking a pound to go. (Photo courtesy of Miller's Pub.)

(*Left*) JIMMY GALLIOS WITH TONY BENNETT. John Davidson, Carol Channing, and Tony Bennett all still come back when in town. The old timers, the Jack Benny's and the like, all knew a secret of life . . . "good food and a smiling face of a good friend"—could always be found at Miller's Pub. (Photo courtesy of Miller's Pub.)

Six

Marshall Field's
Department Store

As the days grow shorter and colder, and you can feel that the holidays are just around the corner, you enter a building that is truly an amazing world of Christmas enchantment—Marshall Field's.

Marshall Field's on State Street is the second largest retail department store in the world. The first is Macy's in New York City, and Harrod's in London takes third place behind Field's.

This chapter opens showing the complete sets of Christmas windows at Field's, including their original captions, from the years 1950 and 1975. Note the exquisite detailing found in each window display.

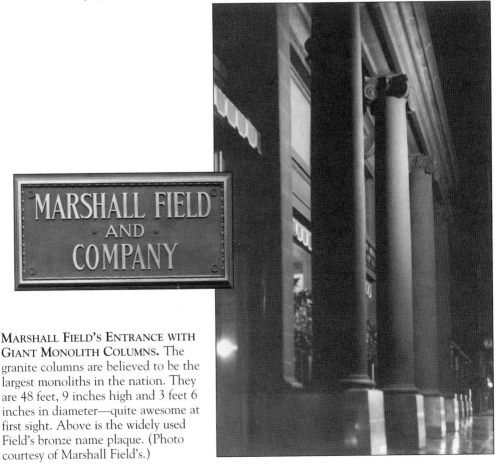

MARSHALL FIELD'S ENTRANCE WITH GIANT MONOLITH COLUMNS. The granite columns are believed to be the largest monoliths in the nation. They are 48 feet, 9 inches high and 3 feet 6 inches in diameter—quite awesome at first sight. Above is the widely used Field's bronze name plaque. (Photo courtesy of Marshall Field's.)

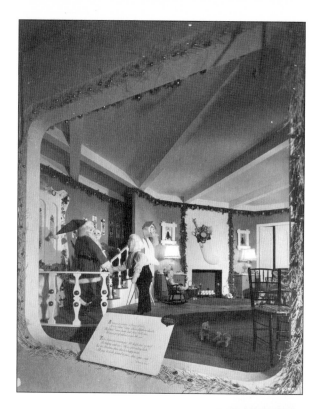

1950 MARSHALL FIELD'S CHRISTMAS WINDOWS.
"A Party for Santa"
A scurry of reindeer
A flurry of bells
At Cozy Cloud Cottage
Where Mistletoe dwells,
"Ho Uncle!" roars Santa,
"And Aunt Holly too . . .
I'd never get off
Without people like you.
You've helped me tremen-jus!
My sleigh and my pack
Are bulging with toys . . .
Oh, my poor aching back!"
But the Mistletoes know
That he's happy inside,
All year he looks forward
To just this one ride!

Says Aunt Holly later,
"It's high time to plan
A Welcome–Home–Gift
For that generous man!
Fetch all of the Animals
Here on your rug."
"I will," chuckles Uncle
And gives her a hug.
(Both photos courtesy of
Marshall Field's.)

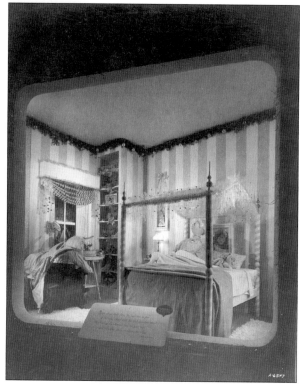

Next day there's a happy
To–do on the stair . . .
"A party for Santa?"
"Well, I do declare!"
"I want to get slippers"
"I'll pick out a pipe"
"Ice Cream!" . . . "And a robe
With a gay candy stripe!"

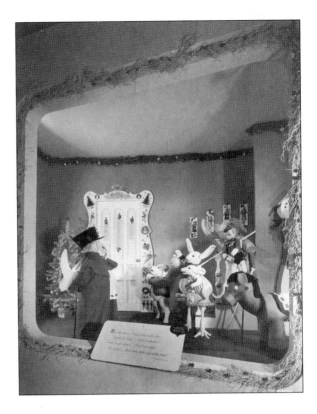

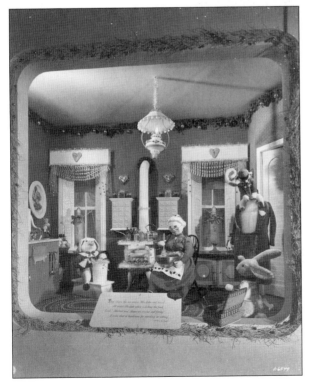

They churn the ice cream.
Mrs. Robin and brood
All watch Obediah
Who's watching the food.
Look! Michael and Skippy
Are sewing and fitting
A robe that is handsome
For standing or sitting.
(Both photos courtesy of
Marshall Field's.)

In Faraway Forest
Where Christmas trees grow,
There's Otto the Elephant
Trampling the snow.
He's making a skidway
As fast as he's able.
To help drag the tree
Into Santa Claus' stable.

Now pull, Otto Elephant—
Uncle, don't fall!
The tree you have chosen
Is three stories tall.
Will it fit in the barn?
Uncle puffs "Never fear!
If they do it at Field's
We can manage it here!"
(Both photos courtesy of
Marshall Field's.)

The barn will have Santa
Amazed and delighted,
His hard-working reindeer
Are also invited.
The tree is all trimmed
To the last lolli . . . Stop!
Oh, where will they get
Something Bright for the top?

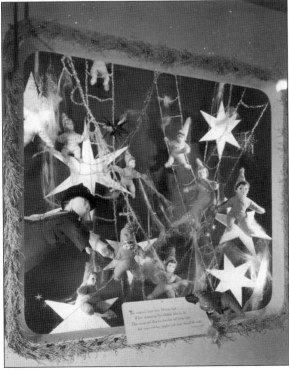

The magical carpet
Takes Mistletoe high,
Where shimmering Star Children
Habit the sky.
They swing and they toss him
Their soft, loving light,
And sweet, tinkling laughter
Falls down through the night.
(Both photos courtesy of
Marshall Field's.)

95

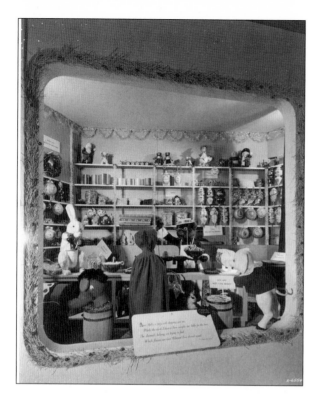

Aunt Holly is busy
With shopping, you see.
While the clerk, Edward Bear,
Weighs out balls
For the tree.
The Animals, helping,
Are trying to find
Which flavors are best.
(Edward Bear doesn't mind.)

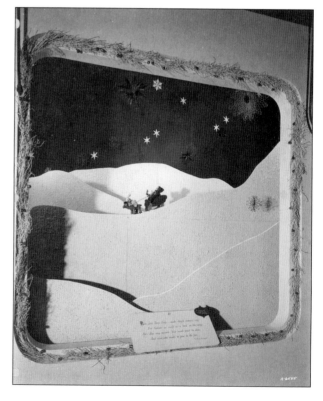

Run fast, Tony Pony . . .
Make sleigh runners sing,
For Santa's as swift
As a bird on the wing:
He's due any minute,
Your work must be done,
And everyone ready
To join in the fun.
(Both photos courtesy of
Marshall Field's.)

"Ah, there you are, Holly,
My goodness, you're late!
Unhitch Tony Pony . . .
Quick, open the gate!"
They hurry inside
Not a moment to spare,
"Now everyone quiet,"
Says Michael O'Hare.

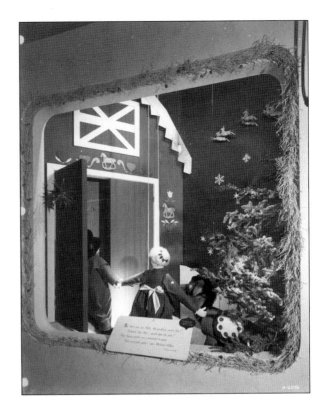

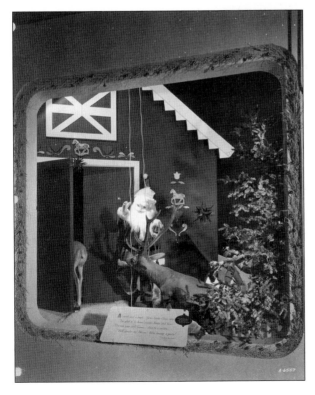

A swish and a jingle . . .
Here's Santa Claus now.
"I'm glad to be home."
Mutters Santa, "And how!
Get into your stall, Comet—
Don't be a smarty . . .
Well, dunder my blitzen,
We're having a party!"
(Both photos courtesy of
Marshall Field's.)

97

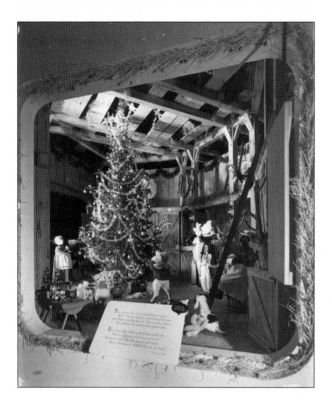

They welcome him in
And the merriment grows.
While Otto the Elephant
Croons through his nose.
And Skippy turns flip-flops.
The Mouse reads a rhyme.
They all shout out carols
In three-quarter time.

And Santa Claus beams
At his friends and his tree,
"The very first party
Whipped up just for me!
My heart is all melty
With joy and with mirth;
Merry Christmas to Children
All over the earth!"
(Both photos courtesy of
Marshall Field's.)

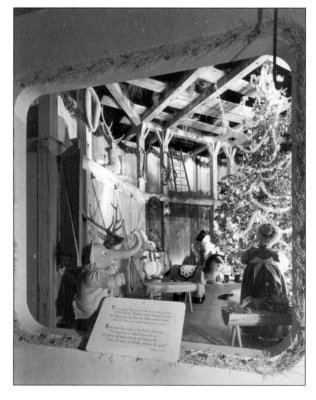

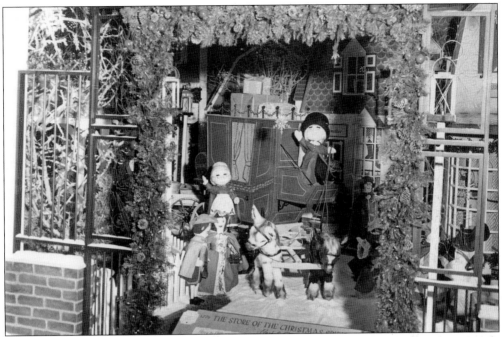

THE STORE OF THE CHRISTMAS SPIRIT. We now jump to the 1975 Christmas windows. Uncle Mistletoe and Aunt Holly are smaller in size and not made of papier-mâché (as in the first set of windows) but of a rubber molded compound.

MARKET SQUARE.

*Here's to The Spirit of Christmas, revived each year through age-old lore—
Come along—Let's go Christmas Shopping!
There's Fred just opening his store—
With Betsy, Benjamin, Aunt Holly—
And dear old Uncle Mistletoe
We'll travel back in imagination
to those Merry Days of Long Ago!*
(Both photos courtesy of Marshall Field's.)

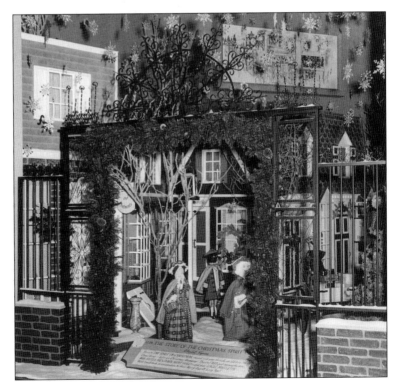

MARKET SQUARE. This photo, along with the two on page 99, shows a view of the set of double windows at the corner of State and Randolph.

THE TOY SHOPPE.
Toy makers, through all the ages, have been inspired by Holiday Joy
To create with nimble fingers many a Special, Hand-Made Toy!
(Both photos courtesy of Marshall Field's.)

THE CABINET MAKER.
Aunt Holly and Uncle Mistletoe
admire that newly-made chair . . .
They can tell that it was designed
and built with Tender, Loving Care!
(Both photos courtesy of Marshall Field's.)

VILLAGE CRAFTSMAN.
*Betsy and Benjamin have a good friend
whom they truly want to delight—
A gift designed by the Craftsman—
Whatever it is—will be right!*

BOW AND REED.
*The Music Master is ready . . . His
rounds and ballads are gay!
Which shall we choose to fill the air,
To Tell The Tale of This Glad Day?*
(Both photos courtesy of Marshall Field's.)

WREATH 'N' WICK.
Aunt Holly shops for Wreaths of Pine . . .
for Candles . . . and Holly Decorations
To "Deck Her Home With Beauty" for
the coming celebrations!
(Both photos courtesy of Marshall Field's.)

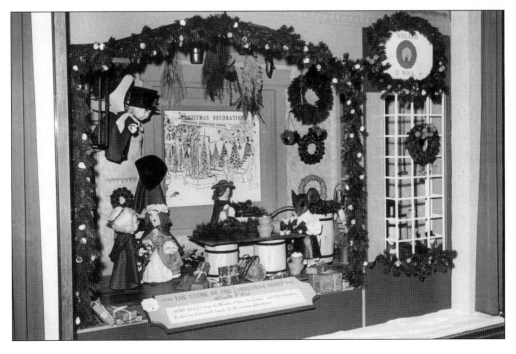

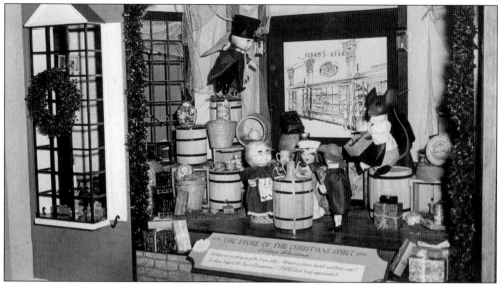

THE VILLAGE WAREHOUSE.
What's as exciting as Gifts From Afar—
What's in those barrels and that crate?
A china teapot for Aunt Clementine?
That she'd truly Appreciate!

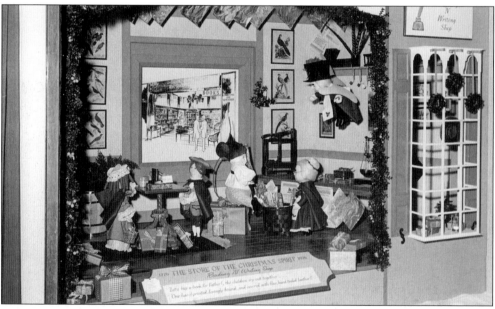

THE READING 'N' WRITING SHOP.
"Let's buy a book for Father!"
the children cry out together—
"One hand-printed, lovingly bound,
and covered with blue, hand-
tooled leather!"
(Both photos courtesy of Marshall Field's.)

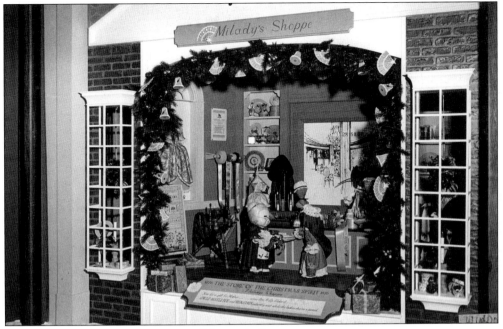

MILADY'S SHOPPE.
Now for a gift for Mother . . .
Some fine, frilly folderol . . .
Uncle Mistletoe and Benjamin
Patiently wait while the ladies
Choose a parasol.
(Both photos courtesy of Marshall Field's.)

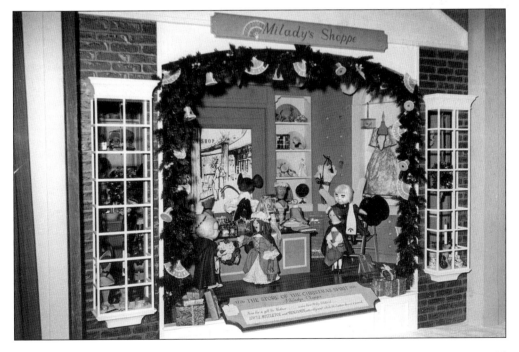

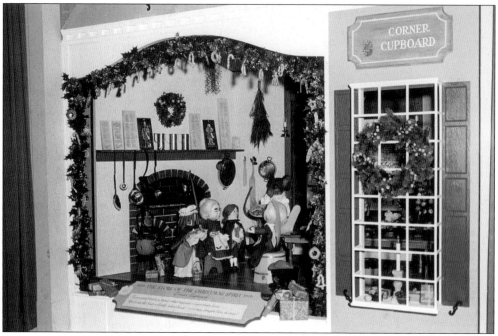

THE CORNER CUPBOARD.
To give good food to a friend—
That bespeaks a heart that's lovin' . . .
Be it colorful fruit or freshly baked bread . . .
Or cookies, straight from the oven!
(Both photos courtesy of Marshall Field's.)

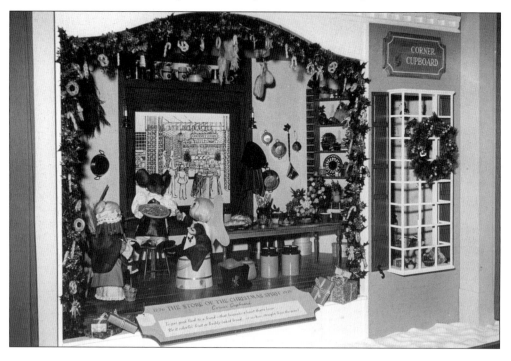

HOLLYDAY INN.

*Now that our shopping is finished,
let's stop to refresh at the Inn . . .
Bring in the Yule Log 'n' light the fire . . .
The festivities will soon begin!
Everyone's excited and happy . . .
the mood is merry and gay . . .
Good Friends . . . Good Food . . .
Good Feelings make for a
Happy Holiday!*

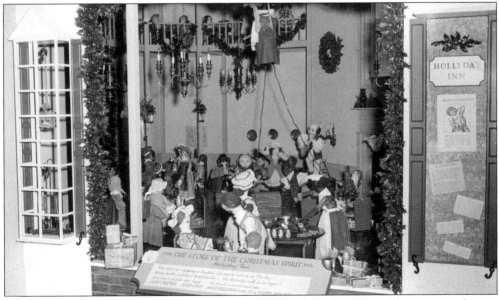

The set of 1975 windows at State and Washington ends with everyone having a real great time. The detail in these windows was truly outstanding—you can imagine yourself a part of the festivities. (Both photos courtesy of Marshall Field's.)

PRINCE CHARLES VISITS MARSHALL FIELD'S. Field's has always been known for doing things in spectacular fashion. Seen here in 1986, Prince Charles cuts the ribbon for the opening ceremony of Field's four month promotion of British goods, "The Eagle and the Crown." With him is Mr. Miller, who was then president of Marshall Field's. The night before Prince Charles dined in The Walnut Room on the seventh floor at a fund raiser for the Field Museum and Salisbury Cathedral. Chicago's movers and shakers paid $500 to $1,000 a plate to mingle near His Royal Highness. The evening raised $250,000. It must have been quite an event. But then that's Field's! (Photo courtesy of Marshall Field's.)

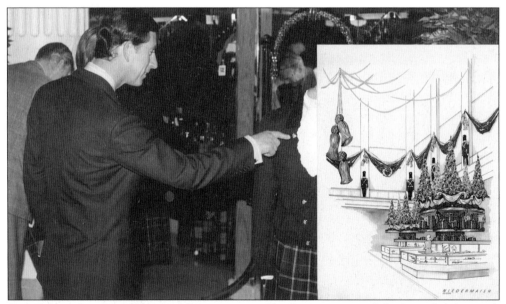

THE PRINCE INSPECTS BRITISH MERCHANDISE. The Prince inspected displays of malt scotch whiskey, woolen skirts, and items made of cashmere and crystal. Prince Charles was quoted in the *Sun-Times* of September 7, 1986, saying, "It's my only chance at going shopping. I am not very keen on it normally." The inset shows a sketch by the Niedermaier Design Company showing the main floor during the British promotion. (Photo courtesy of Marshall Field's.)

FIELD'S ELEVATORS. Looking closely you can just see the Field's coat of arms. At one time it was a familiar sight. Years back the coat of arms was on all of Field's delivery trucks, bags, uniforms, lapel pins, boxes, gold gift tags, and stickers. The original shield was sable and black, which represented the character of the first bearer and meant stability and diplomacy. The roof-like chevron meant protection, and the sheaves of wheat meant wealth and prosperity. Wheat was the chief production of the family. The silver of the sheaves of wheat means that the wealth was the reward of upright dealings. The upper half contains two shocks of wheat, representing a field, hence the Field family. Those two shocks stood for the two older brothers, Chandler and Joseph. The lower shock of wheat represented Mr. Field. The Field's motto was "Säns Dieu Rien," or "Without God Nothing." (Photo courtesy of Marshall Field's.).

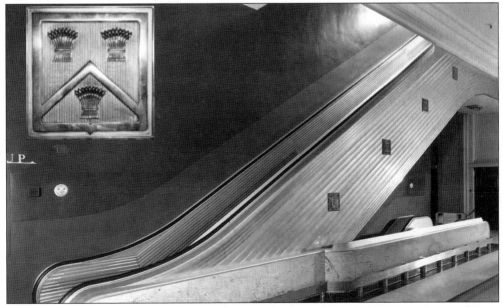

1930s FIELD'S ESCALATOR. The inset shows a close-up of the Field's coat of arms. (Photo courtesy of Marshall Field's, inset photo by R.P. Ledermann.).

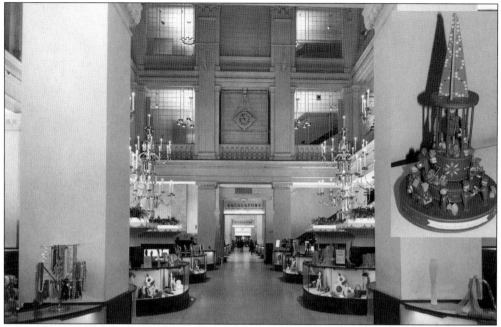

MAIN AISLE BEFORE BEING DECORATED FOR THE HOLIDAYS, c. 1960s. The inset shows a handmade, scale model, which was created on the 13th floor. Using the model as a guide, the figures would then be built to size for the main aisle display. (Photo courtesy of Marshall Field's, inset photo by R. P. Ledermann.)

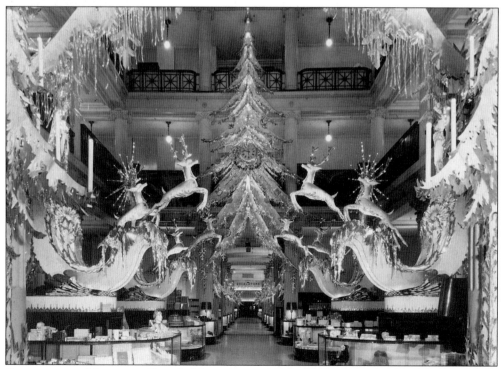

CHRISTMAS IN MARSHALL FIELD'S MAIN AISLE, 1937. (Photo courtesy of Marshall Field's,)

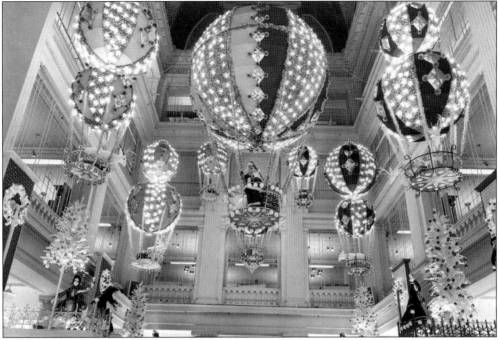

FESTIVE BALLOONS FILL THE MAIN FLOOR WITH SPARKLING SPLENDOR, 1965. Santa is riding in the center balloon. (Photo courtesy of Marshall Field's.)

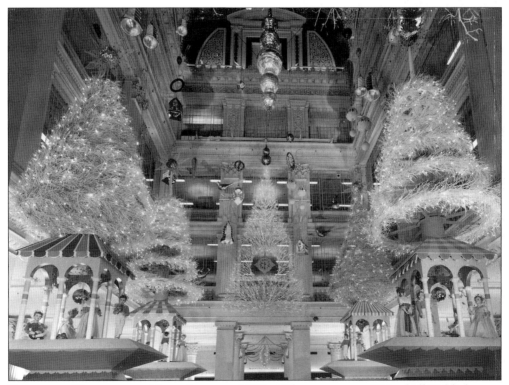

BEAUTIFUL TREES IN THE MAIN AISLE, c. 1950S. (Photo courtesy of Marshall Field's.)

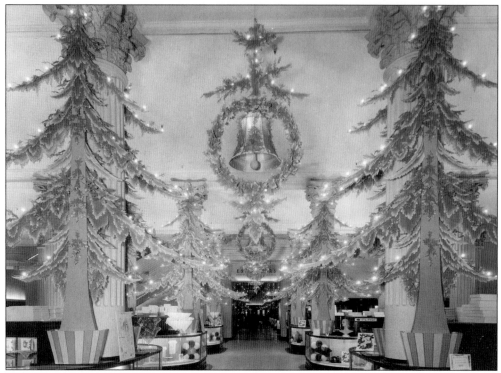

MAIN AISLE, 1942. (Photo courtesy of Marshall Field's.)

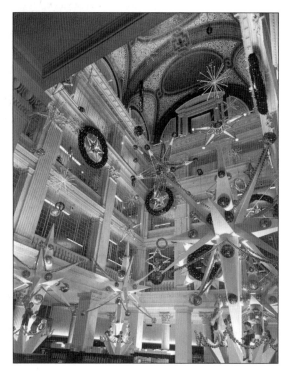

WELCOME TO WONDERLAND

"Welcome to Wonderland, everyone
Where everyone's kind and everything's fun
Where houses of candy
with gingerbread roofs
And the horses wear silver and gold on
their hooves
Where rabbits can talk, and piggies can cook
Just like a storyland out of a book
Welcome to Wonderland everyone
Where everyone's kind
and everything's fun."

MAIN AISLE, 1958. (Photo courtesy of Marshall Field's.)

TOY DEPARTMENT—TRAIN DISPLAY, 1927. The toy department was the highlight of any child's visit. The electric train layouts of Lionel and American Flyer trains, the Lincoln Logs, Tinker Toys, Erector Sets, chemistry sets, drawing supplies, games, and all the other fantastic things boggled the imagination of a child. And don't forget all the dolls and doll houses for the girls, along with complete doll wardrobes with hangers and drawers below for accessories and shoes. There were also miniature kitchens complete with rolling pins and dish sets. A visit wouldn't be complete without stopping by the magic counter, where Field's had a full-time salesman/magician. Can you imagine the faces and eyes of a child gazing upon this toy department for the first time? It was truly a wonderland, and it transports us back to the old words, on page 112, of the children's song "Welcome to Wonderland." (Photo and song lyrics courtesy of Marshall Field's.)

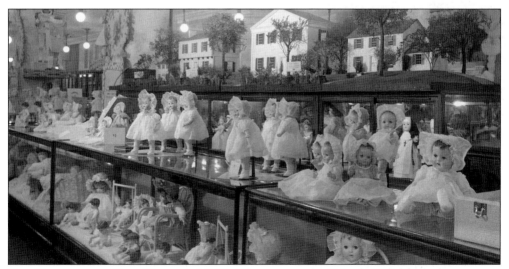

TOY DEPARTMENT DOLL DISPLAY, 1940. (Photo courtesy of Marshall Field's.)

TOY DEPARTMENT ON THE FOURTH FLOOR, 1934. The inset below shows an Uncle Mistletoe lineotype from *Fashions of the Hour*, a Field's catalog. (Photo courtesy of Marshall Field's, inset photo by R.P. Ledermann.)

LIONEL TRAIN DISPLAY, 1932. (Photo courtesy of Marshall Field's.)

CUTTING THE FRESH TREE BASE DOWN TO FIT, c. 1940s. On the seventh floor of Field's is the Walnut Room and The Great Tree. In my first book I described how the fresh tree as well

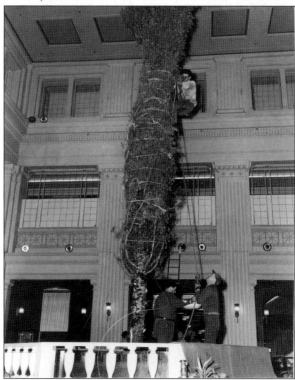

as the artificial trees were put in place. Another artificial fir tree was added in 2003 (see page 70). In the past, all of the ornaments were handmade by the display department employees on the 13th floor. Each year they would have a new theme. One year it was an all Santa tree, one a Victorian tree, one a circus tree, one a Bozo or even an Uncle Mistletoe and Aunt Holly tree. In recent years Field's has had trees featuring Harry Potter, Paddington Bear, and the Grinch. (Photo courtesy of Marshall Field's.)

HOISTING UP THE FRESH FIR TREE THROUGH THE LIGHT WELL, c. 1940s. (Photo courtesy of Marshall Field's.)

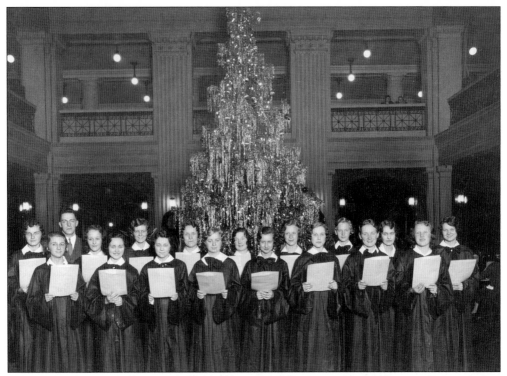

CHRISTMAS CAROLERS FROM THE JUNIOR ACADEMY SINGING AT THE WALNUT ROOM, 1931.
Note how small these fresh trees were. (Photo courtesy of Marshall Field's.)

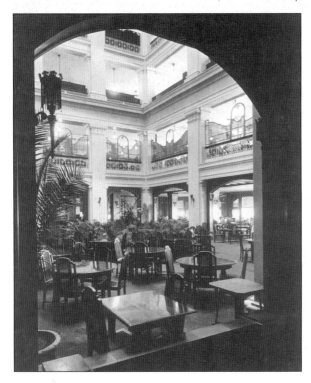

WALNUT ROOM, c. 1930s. The close-up above shows the original walnut crown molding with crystal sconce in the Walnut room. (Photo at left courtesy of Marshall Field's, close-up photo by R.P. Ledermann.)

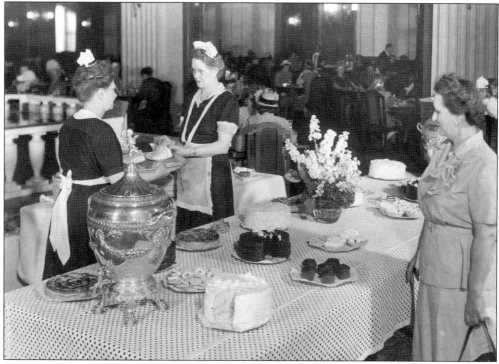

WALNUT ROOM, c. 1940s. (Photo courtesy of Marshall Field's.)

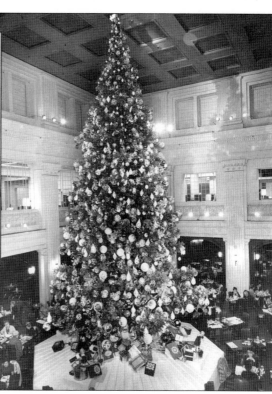

WALNUT ROOM WITH ARTIFICIAL TREE, 1968. The close-up photo above shows one of the hand-made ornaments of years past. (Photo courtesy of Marshall Field's., close-up photo by R.P. Ledermann.)

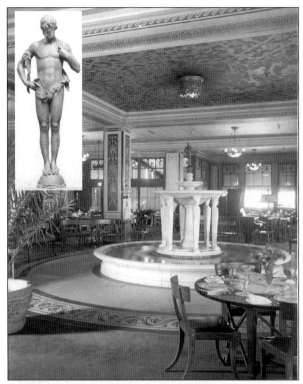

NARCISSUS ROOM. Another fine dining restaurant on the seventh floor was the Narcissus Room. It closed in 1987 and was converted into an employee's lunchroom, and later a special events center. However to this day you can still see the fountain on the northeast side of the seventh floor. The statue atop the fountain was created by Leonard Crunelle (1872-1950), who was the protégé to Lorado Taft, the famous American sculptor. Leonard Crunelle is most famous for the Lincoln Tomb in Springfield, Illinois. (Photos courtesy of Marshall Field's.)

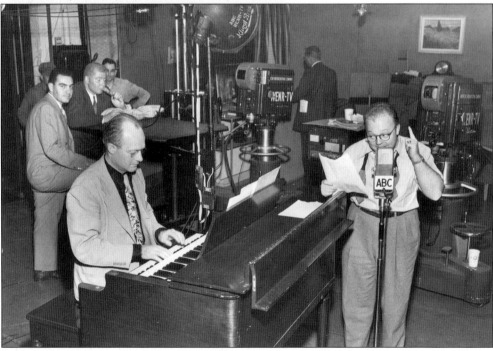

JOHNNY COONS, THE VOICE OF UNCLE MISTLETOE, IN 1950. This photo was taken during *The Adventures of Uncle Mistletoe* television show, at the former penthouse studios in the Civic Opera House (WENR), now WLS. (Photo courtesy of Marshall Field's.)

UNCLE MISTLETOE AND AUNT HOLLY. Every year since 1946, somewhere on the Great Tree, be it the tip top or at the base, Uncle Mistletoe can be found. Aunt Holly came in 1947. They were created by Johanna and Addis Osborne. Uncle Mistletoe appeared on almost everything in years past. From newspaper ads to gift boxes and of course dolls and tree ornaments in different likenesses. In today's Field's, you still can purchase an Uncle Mistletoe/Aunt Holly ornament from the famous Radko collection. It's nice to see he's still around after over 50 years. The inset shows a Field's Christmas box, *c.* 1960s. (Photo by R.P. Ledermann, inset photo courtesy of Marshall Field's.)

CLOSE-UP OF UNCLE MISTLETOE—STILL TO BE FOUND SOMEWHERE ON THE GREAT TREE IN THE WALNUT ROOM. Uncle Mistletoe's creator Johanna Osborne shared her memories with me in a letter of February 2004. ". . . of the dream and reality of Uncle Mistletoe with his warm red coat, his jaunty black coachman's hat with its sprig of mistletoe, his fine white 'fly away' hair, his gauzy wings, coupled with the magic of his flying carpet that whisked him often to consult with Santa Claus at the north pole. He helped Santa in every way to make all the little children's dreams come true at Christmas time.

"Uncle Mistletoe developed out of my brothers and my travel to Norway with our parents—to visit my grandmother and grandfather in the countryside near Lillehamer and Hamar. My Uncle Ola was at the dock when our ship, the *Staveangerfjord*, arrived in Oslo. There he was, a little old gentleman of 70 or so; with his white hair, a merry face, an artist's brimmed hat, bouquet in hand, to 'welcome us home.' A child's dream! A perfect setting! Being good—thinking of others. That was Uncle Ola.

"This memory of a loved old uncle of mine was the beginning of the storied Uncle Mistletoe. This and other simple charming bits of memory—of Addis's little notes to me after evenings spent together—his little sketches of a magic carpet—helped to bring to life our mutual enjoyment of *The Enchanting Tales of the Arabian Nights* we'd both read as children.

"He was a real uncle, a real person."

She asked her designer friend and co-worker at Field's, Marian Schurz, to help her out. In her Rogers Park basement, Marian handmade the first Uncle Mistletoe out of papier-mâché and felt. She made the figure based on Johanna's description and sketches made by Johanna's husband, Addis. (Photo by R.P. Ledermann.)

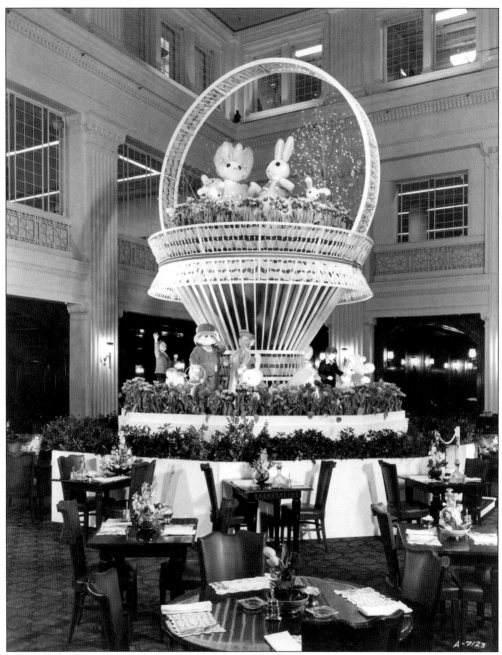

In 1951 Uncle Mistletoe was so Important that Field's used him at Easter Time.
(Photo courtesy of Marshall Field's.)

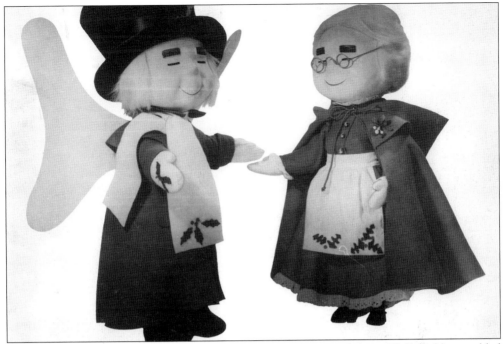

FIELD'S CHRISTMAS CHARACTERS. These Uncle Mistletoe and Aunt Holly rubber molded window figures used in the 1970s and beyond. (Photo courtesy of Marshall Field's.)

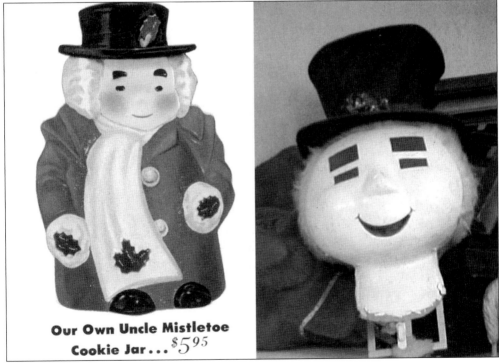

Our Own Uncle Mistletoe Cookie Jar ... $5⁹⁵

(*Left*) ONE OF THE EARLY, c. 1950s COOKIE JARS OF UNCLE MISTLETOE.
(*Right*) ACTOR'S COSTUME HEAD OF UNCLE MISTLETOE. (Photos courtesy of Marshall Field's.)

MARSHALL FIELD'S JINGLE ELF SWINGS OFF FIELD'S CLOCK AT STATE AND WASHINGTON. Below is a giveaway cloth elf doll and a Jingle Elf ornament that was sold in the store(Photos by R.P. Ledermann.)

SANTA BEAR OF MARSHALL FIELD'S MADE HIS DEBUT IN 1985. (Photo courtesy Marshall Field's.)

THE MARSHALL FIELD'S MICE FAMILY, 1980. This photo shows Freddy and Marsha and the four little mice, Forrester, Fanny, Franklin, and Flora. (Photo courtesy of Marshall Field's.)

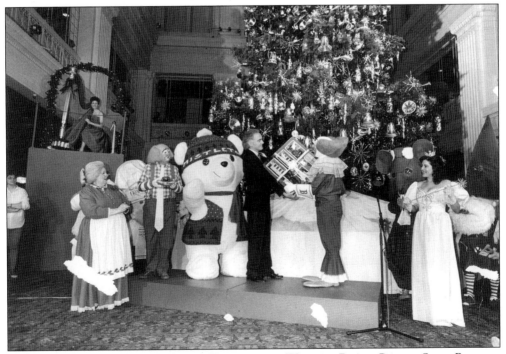

MISTLETOE BEAR UNDER THE GREAT TREE AT THE WALNUT ROOM. Prior to Santa Bear was Mistletoe Bear in the late 1970s. (Photo courtesy of Marshall Field's.)

THE CLOCK MENDER NEXT TO FIELD'S FAMOUS CLOCK AT THE CORNER OF STATE AND RANDOLPH, c. 2000. Another memory synonymous with Marshall Field's is Norman Rockwell's famous *Saturday Evening Post* cover, "The Clock Mender." The original oil painting, depicting a clock mender repairing Marshall Field's famous clock, can be seen on the seventh floor. In 2003 Field's had a reproduction of the clock mender figure placed next to the real clock at State and Randolph, looking just as it does in Rockwell's original. (Photo by R.P. Ledermann.)

BOZO HANDMADE ORNAMENT FOR THE GREAT TREE c. LATE 1970s. (Photo courtesy of R.P. Ledermann.)

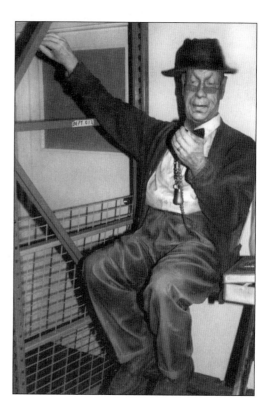

CLOSE-UP OF THE CLOCK MENDER. This is the figure after it was removed from the State and Randolph corner. It was made from a resin composite. (Photo by R.P. Ledermann.)

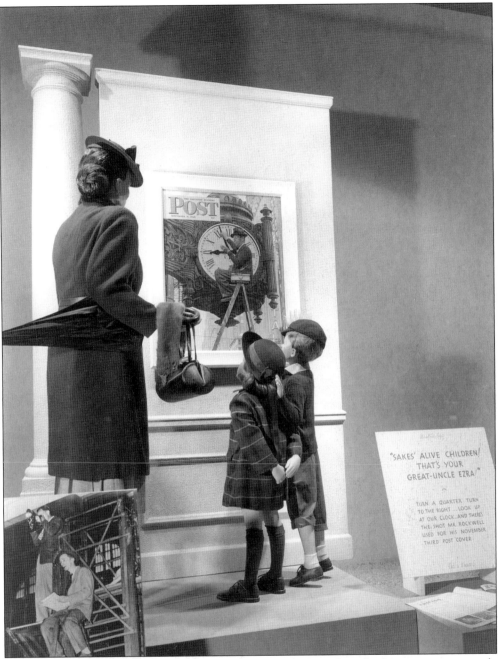

A 1945 Marshall Field's Window Display. This window display portrays a couple children looking at Rockwell's famous Saturday Evening Post cover, *The Clock Mender*. The inset photograph, which was part of the window display, shows Norman Rockwell at work. (Photo courtesy of Marshall Field's.)

RICHARD J. DALEY AND ARTHUR E. OSBORNE. The late mayor is with the Senior Vice-President General Manager of Marshall Field's, Arthur E. Osborne. They are admiring a replica of the mayor lighting Chicago's 1976 Christmas Tree in the Civic Center, which is now Daley Plaza. (From R. P. Ledermann's Collection, taken from an article in the *Field Glass*.)

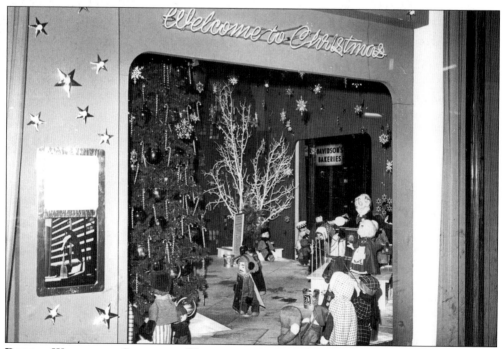

DOUBLE WINDOW AT STATE AND WASHINGTON, 1976. Mayor Richard J. Daley is featured as a character in this window display. When he died on December 20 of 1976, the Daley figure in the window display was replaced by Aunt Holly. (Photo courtesy of Marshall Field's.)

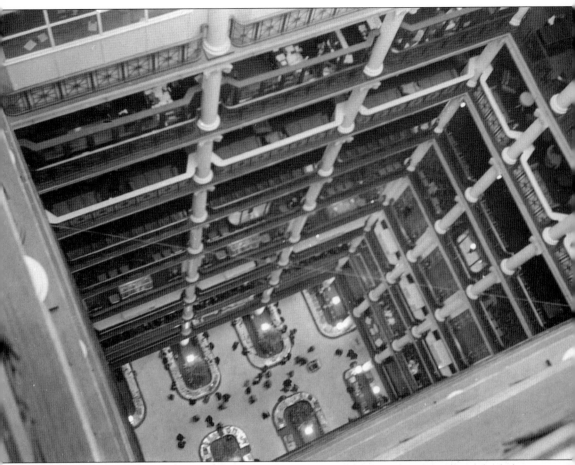

LOOKING DOWN FROM THE 13TH FLOOR. This dramatic view is looking down from the light well at the north end of the Field's building at Randolph and State in 1934. (Photo courtesy of Marshall Field's.)

The Uncle Mistletoe Song

The jolliest man I know
with the merriest Ho-Ho-Ho
You're sure to love him so
Your Uncle Mistletoe
He's gentle and kind, and grand
He's the wizard of Wonderland
Your happiness will grow
With Uncle Mistletoe

(Words and music by Leonard Whitcup and Ray Madison. Reprinted with permission from Herzog and Strauss of N.Y. and courtesy of Marshall Field's.)

In his bright red coat and his tall
top hat he brings you fun and pleasure
In his magic way he will help you play
And fill your life with treasure.
When Santa makes up his list
You know that you won't be missed,
cause who tells him where to go—
Your Uncle Mistletoe.

FIELD'S, c. 1940s, HAD THEIR OWN DRUG STORE THAT FILLED PRESCRIPTIONS. (Photo courtesy of Marshall Field's.)

WAITING ROOM AND VISITOR'S BUREAU IN 1949. This visitors center, located on the third floor, allowed guests to send and receive telegrams, consult railroad timetables, use a long-distance telephone, buy tickets, and leave messages for friends. Note the around the world clock, showing nine different time zones; New York, Havana, London, Paris, Berlin, Manila, Tokyo, Honolulu, and San Francisco. The clock was built by German clockmaker August Hahl, c. 1895, and can be seen today in the archives on the seventh floor. (Photo courtesy of Marshall Field's.)

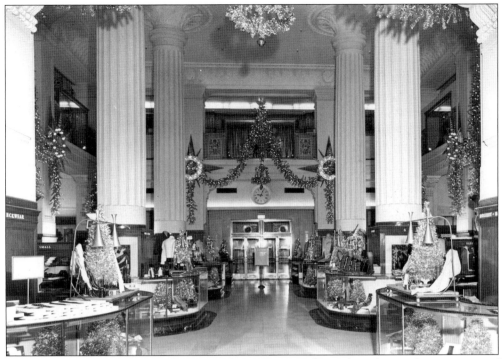

STORE FOR MEN ANNEX. In the 1960s the Annex was located at the southwest corner of Washington and Wabash, but it no longer exists today. (Photo courtesy of Marshall Field's.)

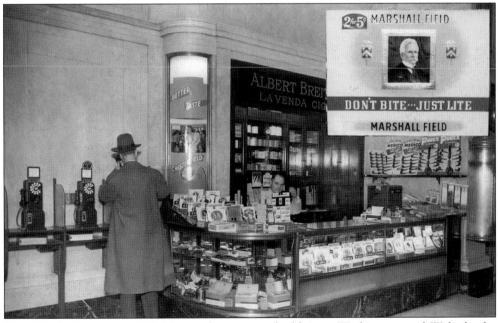

THE MEN'S ANNEX IN 1943. Located in its own building at Washington and Wabash, the Annex had a tobacco shop in its lobby. Note the pay phone on the wall with the rotary dial. The inset shows the top of a cigar box, featuring "2 for 5 ¢" Marshall Field's house cigars. (Photo courtesy of Marshall Field's, inset photo by R.P. Ledermann.)

JEWELRY DEPARTMENT IN THE "BARGAIN BASEMENT," 1922. At Christmas time and throughout the year shoppers enjoyed the bargain basement, in what is now simply called The Lower Level. (Photo courtesy of Marshall Field's.)

FRANGO MINTS. This 1963 photo shows bargain basement shoppers looking over Field's famous Frango mints in the candy department. (Photo courtesy of Marshall Field's.)

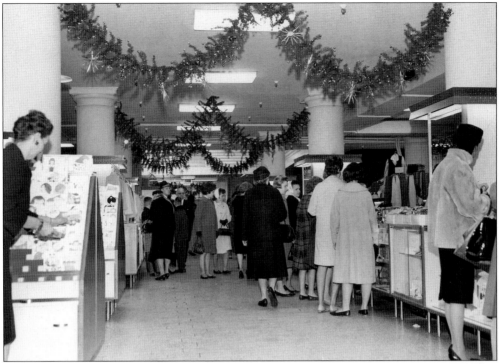

WOMEN'S DEPARTMENT IN THE BARGAIN BASEMENT, 1963. (Photo courtesy of Marshall Field's.)

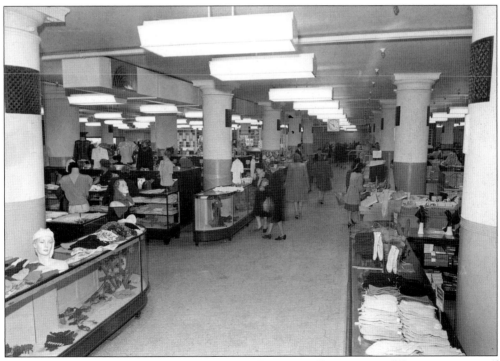

FASHION ACCESSORIES OF 1946 IN THE BARGAIN BASEMENT. (Photo courtesy of Marshall Field's.)

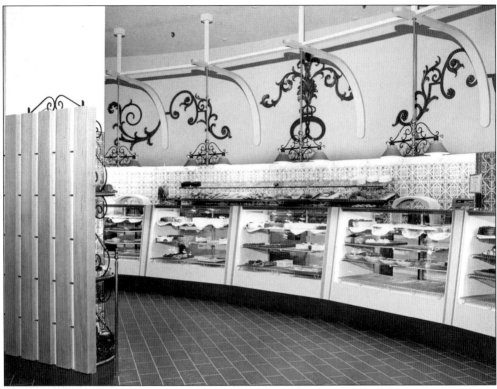

THE BAKERY IN 1970 WITH TILED WALLS ON THE SEVENTH FLOOR. (Photo courtesy of Marshall Field's.)

THE "ARCHIVES" ON THE SEVENTH FLOOR REPLACED THE BAKERY. (Photo courtesy of Marshall Field's.)

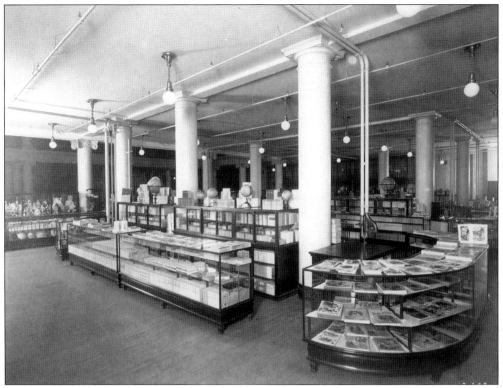

CHILDREN'S BOOK DEPARTMENT, c. 1920S, LOCATED ON THE THIRD FLOOR. (Photo courtesy of Marshall Field's.)

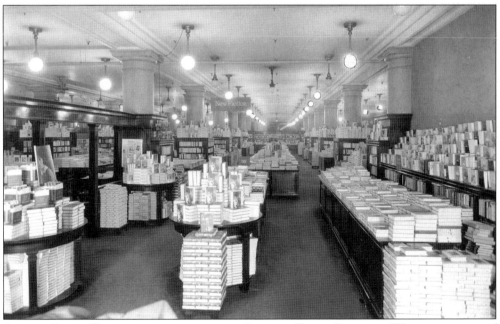

ADULT BOOK DEPARTMENT WITH THE LATEST BEST SELLERS. (Photo courtesy of Marshall Field's.)

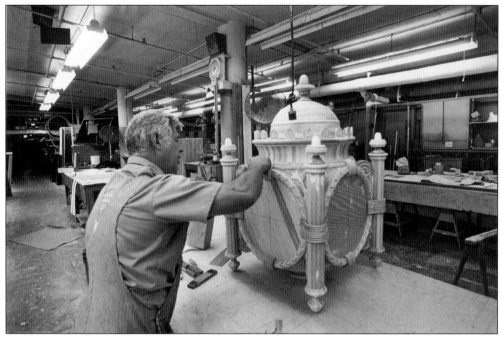

MASTER CRAFTSMAN IN 1979. Working in the 13th floor carpentry shop, this craftsman is carving a wood model of Marshall Field's famous clock. (Photo courtesy of Marshall Field's.)

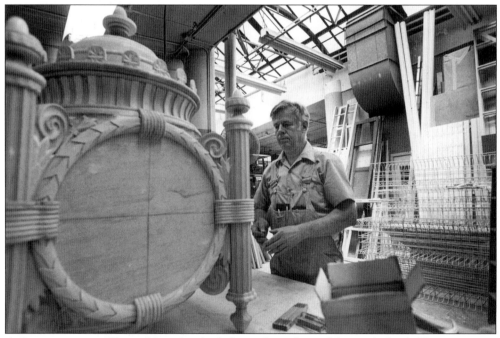

A CRAFTSMAN AT WORK. Note the sky-light in the ceiling of the work shop. (Photo courtesy of Marshall Field's.)

WORKSHOP WITH SECTIONS OF MODEL CLOCK WAITING TO BE ASSEMBLED IN 1979. (Photo courtesy of Marshall Field's.)

RAINEY BENNETT'S 1965 SKETCH OF THE FAMOUS MARSHALL FIELD'S CLOCK. The small photo above shows an animated Uncle Mistletoe and Aunt Holly. (Photo courtesy of Marshall Field's, inset photo by R.P. Ledermann.)

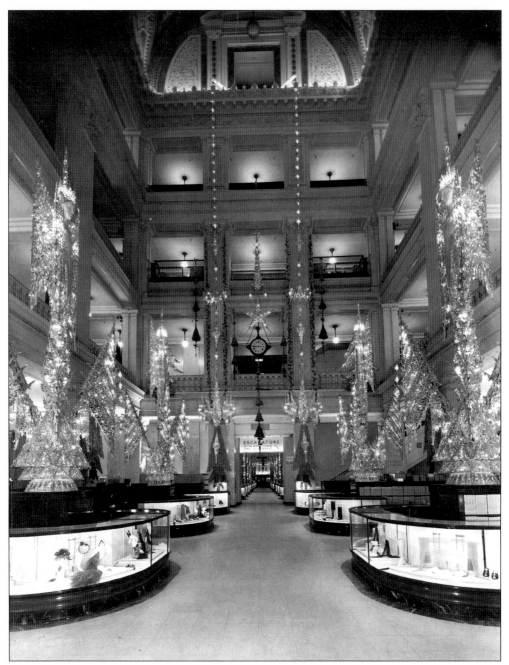

Main Aisle, c. 1930s, with Flood Lights Highlighting each Floor. (Photo courtesy of Marshall Field's.)

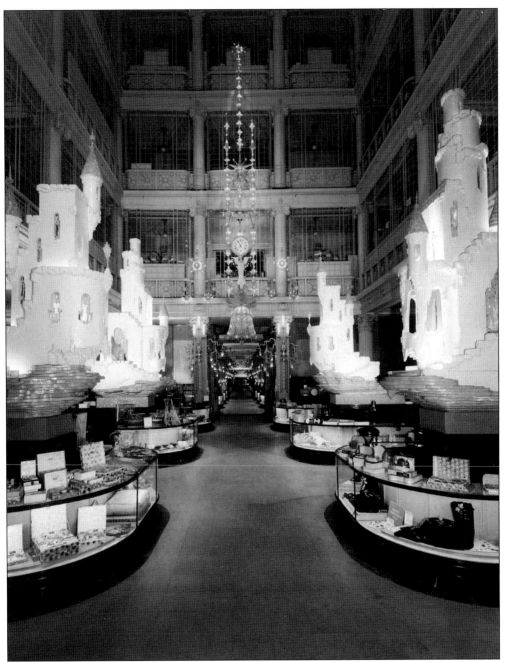

MAIN AISLE IN 1939. (Photo courtesy of Marshall Field's).

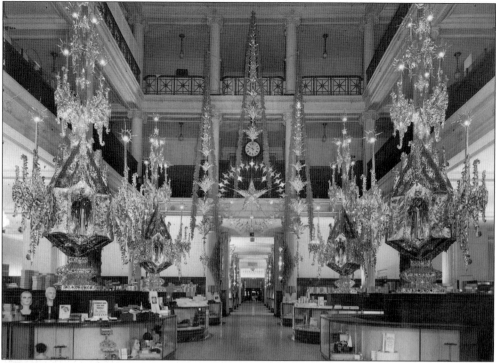

MAIN AISLE c. 1930S. (Photo courtesy of Marshall Field's.)

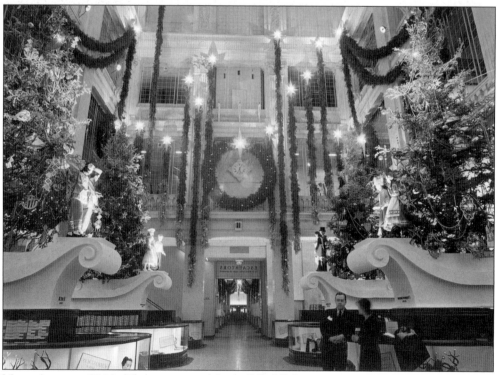

MAIN AISLE IN 1944. (Photo courtesy Marshall Field's.)